# Modeling With Self-Hardening Clay

The Larousse Craft Series

# Modeling With Self-Hardening Clay
## Gary Tong

Larousse & Co., Inc.
New York, N.Y.

*For my parents.*

First published in the United States by
Larousse and Co., Inc.
572 Fifth Avenue
New York, N.Y. 10036
1976

©1976 by Larousse & Co., Inc.

*ISBN 0-88332-047-9 (hardback)*
*ISBN 0-88332-048-7 (paperback)*

Library of Congress No. 76-15924

*Printed in the U.S.A.*

# Table of Contents

# Introduction

Ordinary clay, used as a raw material in art, must pass through several transformations before it can become a permanent creation. First molded, then fired in a kiln at high temperatures, the water-permeable and easily crushed clay changes into a hard, water-resistant substance: ceramic. Application of colored glazes to ceramic pieces requires one more firing. Clay can also be used as a modeling material only. The resulting prototype is then cast or copied in more permanent materials such as plaster, marble, or bronze.

In contrast to ordinary clay, self-hardening clay does not need to be wedged (freed of air bubbles) or fired in a kiln, because added ingredients enable this clay to dry hard and durable without being subjected to high temperatures. When one is working with ordinary clay, great care must be taken to wedge it. A clay piece with closed air pockets may explode in the kiln. This crucial task of wedging is not necessary with self-hardening clay.

When dry, pieces made of self-hardening clay can be finished and decorated in many interesting and attractive ways. Unlike kiln-fired clay, the self-hardening kind remains permeable to water and becomes waterproof only after the application of a suitable finish.

This book describes in detail a technique for modeling with self-hardening clay. The pieces included are small in size, usually with no dimension larger than 6″. Limiting the size makes construction easier and enables one to complete a piece at home in a relatively short time and in limited work space. Of course, the reader can build pieces to any size simply by proportionally increasing the dimensions suggested. However, when working with larger sizes measured in feet instead of inches, the technique itself must be somewhat changed to deal with the increased weight of the clay (more on this subject in the section on measurement and layout in chapter 4).

The projects range in difficulty. They provide material for beginners as well as for those with experience in clay-working. The methods include hand-forming, slab-building, and impressions, as well as carving, a process not often applied to clay but one that yields unexpectedly professional-looking results and is as easy and pleasant as sculpting soap.

The pieces to be built fall into several categories: containers, animals, figures, heads, masks, abstract sculptures, miniatures, and ornaments. Although you may wish to construct the pieces in Section I, which have detailed instructions that include all the basic techniques needed to construct those presented in less detail, many of the simpler projects can be built without any application of special techniques.

# 1. Getting Started with Clay

Self-hardening clay is sold moist and ready for use, usually in five-pound packages. This amount is enough to make up to ten average-sized pieces from those included in this book. Larger quantities of clay can be bought or ordered economically from a supplier of sculpture materials (see the list of suppliers, page 96). Gray, green, brown, and terra cotta are the clay colors generally available. The gray is not very attractive, but the other colors are handsome.

You should note that the color of wet clay becomes much lighter as the clay dries. The original dark tone returns only when you apply a glaze.

If you try working with different brands of clay, you may find some difference in the way they handle. This variation is due mainly to differing amounts of *grog* (clay that has been fired and crushed to a powder) in the clay. When added to fresh clay, grog reduces shrinkage due to drying. With an increase in the amount and coarseness of the grog, the clay not only dries more quickly but also becomes more open-grained, grittier, and more matte in appearance when dry.

To take some clay from its package, open the cardboard box, turn it upside down on the table, and shake the block of clay, wrapped in plastic, out of the box. Unwrap the plastic and slice off the amount of clay needed, using a kitchen knife or a wire cutting tool. Rewrap the remaining clay tightly in its bag. Wrapping clay in two plastic bags will help keep it moist for some time.

## How to Keep Clay

Keeping clay moist over several months requires special attention. Wrap it in wet cloth and place it in an airtight container. Check it occasionally and rewet cloth if necessary. If left in its original package, clay will dry out completely in a month or two.

## How to Make Clay Wetter

If a small piece of clay is not moist enough, dip the clay in water and then knead it until the water is absorbed by the clay. With large pieces, proceed by tearing or cutting the clay into small chunks. Dip each one in water, then stick the chunks together, and knead till the water is uniformly absorbed and the clay becomes workable.

## How to Make Clay Drier

If the clay is too wet, spread it on a plaster bat (see Tools and Materials, page 13) or on newspapers and let stand for a few minutes. Then scoop the clay together, knead it, and repeat the procedure until the clay becomes stiffer and more workable.

## What to Do with Waste Clay

Chunks and shreds of waste clay, the by-

product of cutting and carving, will quickly dry out if unattended. There are two ways of saving these pieces:

1. You can put clay waste, while still moist, into a closed container. This collection can later be fully reconditioned by adding more water and kneading.

2. You can cut the soft waste pieces into small shreds with a razor blade. Even when dry, thin shreds can easily be reworked to plastic condition.

### How to Recondition Dry Clay

Put a small amount of water into a bowl and throw in the clay scraps. (Remember to put the clay into the water, not the other way around, or else you'll end up with a slush filled with hard clay particles.) Once the clay scraps have settled, pour off the excess water. Keep the wet clay standing in the bowl and stir it occasionally until it becomes a homogeneous mass. After this, the clay needs only to dry. As soon as the clay is solid enough to hold together, scoop it up and dry it further on a plaster bat (or substitute).

Ideally, you should never be confronted with a big block of dried-up, hard clay, but if this happens, you can recondition it. Put the clay in a plastic bag (or leave it in its bag if you haven't removed it), add water (about one-half cup per five pounds), close the bag, and let the clay sit for several days

## Relationship between Clay Moistness and Suitable Work

| Degree of Clay Moistness | Characteristics of Clay | Suitable Work |
|---|---|---|
| Slip | Thick, heavy, slow-flowing liquid. | Joining pieces or applying to pieces as a special finish. |
| Plastic stage | Shiny; easy to mold, stick together, model, pull, compress. Doesn't crack when worked over. Stays in shape, but thin structures will sag and bend. Too soft to carve. | All modeling, slab-making, joining, and impressions. |
| After plastic stage | Clay doesn't handle smoothly anymore but cracks when modeled, pulled, or compressed. Does not carve cleanly yet. | First drying stage (no work done on clay). |
| Leather-hard stage | Clay is matte, carves easily. Blade leaves clean surfaces (as if clay were leather or soap). | Carving, which is possible only at this stage. Impressions of small size. |
| After-leather-hard stage | Clay cracks when carved. | Final drying stage; corrections can be made. |
| Dry clay | Clay is matte and light in color; it cannot be scratched with fingernail. | Finishing, sanding, painting, glazing, etc. Late corrections in carving still possible if area in question is rewetted. |

until it is moist. Add more water if the clay has absorbed all the water and is still not thoroughly moist, but only a little at a time.

**Slip**
Slip is a mixture of clay and water that is used to join parts of clay pieces; it can also be applied as a decorative coating to finished pieces.

**How to Make Slip**
Clay slip is made by dissolving clay in enough water to produce a slowly flowing paste, similar to thick cream. To make enough slip for at least one project, put about 1 or 2 tablespoons of water in a container and then, using your fingers, a spoon, or a piece of wood, squash and stir a pinch of moist clay till it is well dissolved. Keep adding more clay, squashing and stirring it, until the clay-water mixture reaches the right consistency. Naturally, slip should be made from clay of the same color as the one you are using to build your piece.

**Storing Slip**
Slip dries up if left uncovered in a container. If you wish to use slip for more than one session, keep it well covered in an airtight container such as a food jar.

In order to work successfully with clay, it is important to understand that the working qualities of clay differ with the amount of moisture contained in the clay. For example, when it is to be modeled, shaped, pressed, or joined, clay must be softer than when it is to be carved; clay that can be carved well is much too dry to be modeled or joined. The kind of work possible with clay, depending on how much moisture it contains, is shown in the table.

# 2. Tools and Materials

### Balsa Strips

These strips are used in slab-making as a gauge to ensure uniform slab thickness, and also for propping up pieces to dry. A good size is the ¼″x ¼″ strip, which gives ¼″-thick slabs, ideal when building small pieces such as those in this book. If you decide to work on a larger scale, you'll need thicker slabs and should use correspondingly thicker gauges. Strip balsa is sold in standard lengths of 36″, and one such length is all you need to start with.

Balsa strips are also good for marking guidelines into a clay slab. (Lightly press the long edge of the strip into the clay to leave a perfectly straight line.)

As a substitute for balsa strips you can use pencils, rulers, boxes, books, and so on.

### Brushes

You need two inexpensive artist's brushes. One is used to apply slip (see page 10) or water to clay; the other one is useful in cleaning your work of waste clay shreds when carving. Flat (*not* round) brushes, no wider than ¼″, are best. The brushes may be bristle, camel, or sable. For fine details, use a pointed camel's-hair or sable brush.

### Drinking Straws
Straws are used to punch holes and to make ornamental discs of uniform size.

### Flexible Steel Palette

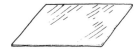

This is a small, thin sheet of steel that comes in several shapes and sizes. A 2″x 4″ rectangular palette is ideal for slicing clay blocks too large to be sliced with an X-acto knife.

### Impression Tools
Any object that leaves a decorative relief when pressed into clay can be used as an impression tool. Most homes are full of things you can successfully employ: screws, nuts, bolts, and other hardware; pencils, pens; buttons; jewelry; and so on.

### Plaster Bat
(optional but recommended)

Plaster bats are inch-thick slabs of plaster of paris that are used as a nonstick work surface. If you model clay or roll it into a slab on a surface of hard wood, linoleum, or Formica, you may find that the clay adheres to the work surface and cannot be picked up without becoming distorted or broken. This strong adhesion is caused by too much water in the clay. Plaster, an extremely absorbent material, avoids the problem by drawing excess water from the clay.

The quick drying of excessively moist clay is another service the plaster bat provides, but a substitute is easily available: newspapers.

Plaster bats come in several sizes and shapes, and for the projects in this book any shape is acceptable, as long as the work surface of the bat is at least 100 square inches.

Plaster bats are not carried by small art stores, but can be ordered from suppliers of sculpture materials, either directly or through an art store (see Suppliers, page 96).

If you wish to, you can cast your own plaster bat by pouring a mixture of plaster of paris and water into a cardboard box lid or other suitable mold.

As a substitute you may use plywood, newspapers, cloth, or the underside of oilcloth, but I recommend the bat, especially when modeling and constructing pieces from slabs.

## Plaster Chisel

This steel tool comes in many shapes, but you will need only the chisel-ended one. The width of the blade can be somewhere between ¼″ and ½″—for instance, ⁵⁄₁₆″.

The plaster chisel is used to scoop and carve clay pieces, especially once they are too stiff for you to use a wire-end modeling tool (page 15). When you build a box, the chisel is the only tool suitable for planing the inner walls. (The tool's round end is not used in our modeling procedures.)

An ordinary woodworking chisel may be used as a substitute, but it is much sharper and considerably more dangerous than the relatively dull-edged plaster chisel. After some use, the plaster chisel will become dull and will need resharpening on an oilstone or whetstone.

## Rolling Pin

The common kitchen rolling pin is the most convenient tool for making slabs. As a substitute, you can use any smooth and cylindrical object (for instance, a thick dowel or a wine bottle). Slabs can also be made in a less convenient way by pressing clay down with a board.

## Small Planks of Wood

(any kind of lumber you have around the house)
These are used for flattening and forming clay.

## Toothpicks

Use these to draw lines and other marks on clay.

## Wire Cutting Tool

A thin, tautly stretched wire is the best tool for cutting *soft* clay. While substitutes (such as a kitchen knife or steel palette) can be

used, wire gives the cleanest cut. Although steel wire (guitar or piano strings) is the stiffest kind, any sufficiently thin and strong wire, even nylon fishing line, will cut clay that is soft enough. Many people use the thin, galvanized iron wire used in making beaded flowers. To make the tool, wrap each end of the wire around a short dowel or other piece of wood. The length of wire between the handles should not be too much longer than the piece of clay you are working with, because with increasing wire length the downward force cutting the clay decreases.

For working with the pieces described in this book, the cutter should be 4" to 6" long; taking into account the wire ends wrapped around the handles, you need about 8" to 10" of wire to construct the tool. Notches cut into the wood—or just some tape—will prevent the wire from slipping. (Don't snip off the end of wrapped steel wire too close; the short wire is stiff and sharp and is sooner or later sure to prick your fingers. To help prevent this, you can wrap the steel wire ends with tape.)

## Wire-End Modeling Tools

These are used to cut shavings from soft clay. The tools consist of a cutting loop made of watch-spring steel attached to wooden, or sometimes aluminum, handles. Just like wooden modeling tools, the wire tools come in various shapes and are anywhere from 6" to 8" long. Try to have at least two 6" tools that provide four different cutting ends: one small round end, one large round end, one small flat end, and one large flat end. Wire-end tools with miniature cutting loops are also available. These so-called thin-line tools serve in modeling fine details. A small loop of steel wire, the thickness of a common pin, attached firmly to a handle, is a good homemade substitute.

## Wooden Modeling Tools

These tools are made from hard, fine-grained woods, such as boxwood, and are used to model and smooth clay, especially where fingers cannot reach. A great variety of shapes is available, in two lengths: 6" and 8". For small modeling, two 6" tools are sufficient. Be sure to get tools that provide at least one small and one large round end. The other two ends can be square, toothed, knife-shaped, and so on.

Combination wooden and wire-end modeling tools are also available.

## X-acto Knife

This knife is essential for slicing, carving, and scoring clay. The #1 X-acto handle with a #11 blade is best for your purposes. You will notice that clay dulls your blades; replace them as soon as they no longer cut cleanly.

## Single-Edged Razor Blade
This is used for planing sides of pieces. Like the knife blades, razor blades should be replaced when they no longer cut easily or when they leave rough surfaces on the clay.

# 3. Setting Up a Working Area

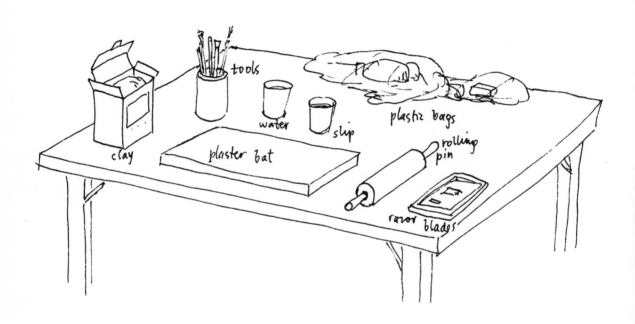

Your work in clay can easily be done on a table of average size, such as a kitchen or card table. The work area should provide enough room for the clay supply, plaster bat (when needed), rolling pin, plastic bag(s) for drying pieces, and three or four drinking glasses (or paper cups) to hold water, slip, and tools. It is a good idea to keep razor blades, which are easily mislaid, in a shallow box or on a plate.

Although clay is an easy material to clean up, the following should be kept in mind: *clay washed down the drain will clog the plumbing.* To avoid this, always remove as much of the clay as possible from tools and hands before washing them in a sink. The dried-on clay can be removed either by scraping or by wiping with a wet cloth or paper towel.

# 4. Basic Techniques

## How to Make Basic Shapes

*Rolling Cylinders and Coils*

Everyone knows how to roll cylinders and coils, but some details may be pointed out here. When you roll a coil or cylinder, keep your fingers separated and bear down lightly, with only enough pressure to keep the clay rolling (1). (Too much force creates a rippled surface.) Keep rolling the clay in this manner until you have a coil or cylinder of desired length and diameter. Drop the cylinder on both ends to flatten them properly.

*Forming Balls, Pellets, Small Discs, Square Lozenges*

*Balls:* Form a ball by rolling a lump of clay between the palms (2).

*Pellets:* Make loosely shaped discs by forming small balls of clay between the thumb and index finger (3) and then flattening them (4).

*Small Discs:* Circular discs of uniform size are made by pushing a 1″ to 1½″ length of straw (or other stiff tube of desired diameter) into the clay (5a). Use a blunt instrument or a cylinder of tightly rolled paper to push the clay rod out of the straw (5b); when the rod is dry enough to cut without distorting its shape, slice off discs with a blade (6).

*Square Lozenges:* Cut a strip from a slab (7). When this strip is dry enough, slice it into square lozenges (8).

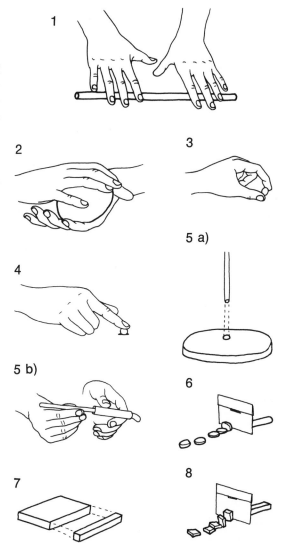

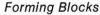

9  a)    b)    c)

13

## Forming Blocks

A block can be formed using a wooden board (or lumber scraps). Take a lump of clay (9a) and pat it down with the board (9b). The surfaces of the board and the bat should be kept parallel as much as possible. This will give you two flat surfaces (9c). Repeat this procedure to shape the remaining two pairs of sides.

10

Another method of making cubic, rectangular, or many-sided blocks is to start with a lump of clay (somewhat larger than the final block you aim to make) and form the top and bottom surfaces by pressing the lump down with a wooden board (10). Then use a steel palette to cut the remaining vertical sides (11, 12). If you need to, mark out the vertical sides before cutting (13).

Since shaping basic forms requires the clay to be relatively soft, the forms produced can lose their shape somewhat, either through rough handling or because of their own weight. Correct the shape when necessary by pressing the clay with your hand or a board.

## Slab-Making with a Rolling Pin

To roll a slab, place two slab-thickness gauges (strips of balsa wood) on the bat (14). Then take a lump of clay and flatten it somewhat with your hands, but leave it thicker than the gauges. Place the clay between the gauges (15), and flatten it out with the rolling pin (16). Roll in different directions—and on both sides—to make the clay spread uniformly.

### Problems in Slab-making

Flattening clay into slab form is an easy process only if the clay has the right degree of moistness. If the slab sticks to the bat and/or rolling pin, the clay is too moist. Decrease the moistness of the clay (see page 9 ). If the slab cracks around the edges while you flatten it or when you pick it up, the clay is not moist enough. Increase the moistness of the clay (see page 9 ).

11

14

12

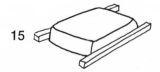

15

18

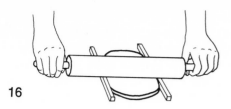

16

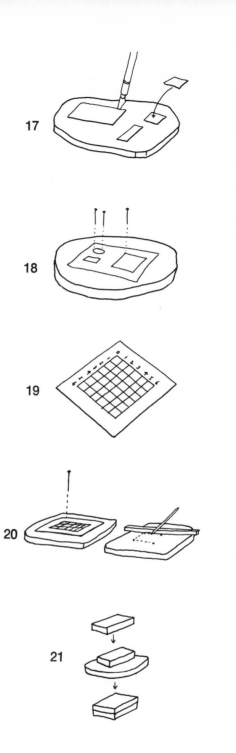

17

18

19

20

21

22        23

## Measurement and Layout

If you wish to follow the measurements given in the project instructions, several methods are open to you. However, first note that the measurements are given not in inches but in *units.* The scale of the illustrations is such that the *unit* here equals ¼″, the thickness of the balsa strip. This small size is very convenient to work with and results in pieces with a certain charm.

Instead of using an inch scale ruler, it is convenient to make your own scale of units on the edge of an index card.

### Slabs

Before you draw construction lines on the slab, make sure it is not stuck to the bat (due to rolling pressure), or else the lines will be distorted when the slab is lifted. Several methods of measurement and layout follow:

1. You can first cut the pattern out of paper and then use this pattern for cutting the desired size and shape from the slab (17), or

2. Draw the pattern on paper, place it over the slab, mark corners with a pin, and connect marks (18), or

3. Draw a grid with lines 1 unit apart on a piece of paper (19). Place this grid over the clay slab, and mark out with a pin the desired size by pricking the clay through points on the grid paper. Wax paper or plastic wrap sandwiched between the clay and the paper will keep the grid dry. Complete the layout by connecting the prick marks (20).

4. If you like to improvise, you can use a method where successive parts determine one another's sizes (after cutting one part, you use it for copying other parts). A box can be used to illustrate this self-generating method (21, 22, 23).

5. If working by eye is easy for you, you can do measurement and layout directly on the clay with a unit scale and a toothpick.

*Blocks, Cylinders, and Others*

These forms should first be made to a size and shape larger than required and then cut to size.

*Important note:* The unit measurements and relative proportions of parts given in the projects are only general suggestions. But although the actual size and proportions of the pieces are left up to the reader, some practical limitations should be kept in mind. As the size of a piece becomes greater, the piece dries much more slowly and, because of its increased weight, may need special supports to prevent collapse. In addition, to work the larger surfaces, tools and methods somewhat different from those used in this book may be needed. Also, the degree of enlargement depends on the piece in question. Some, such as masks or boxes, can be built much larger, while others, such as ashtrays (if enlarged without changing the proportions of the components), would no longer serve their purpose. Still, if the proper methods are employed in relation to the size of the work, there are no special limitations.

If you prefer larger pieces, use thicker balsa strips (or other slab gauges). In this case, the unit measure would equal the height of your gauge.

Projects consisting of a single slab can easily be made larger (at least up to a square foot in area) since they dry lying flat. However, beyond a certain size they could become excessively bulky and heavy for hanging on a wall because the slab must be correspondingly thicker to avoid breaking.

**Cutting Soft Clay**

*Cutting Slabs*

To cut the shapes that you have marked out on the slab, a knife is the most efficient tool. (When cutting with a knife, it is a good idea to put cardboard or sheets of paper under the slab to protect the bat.) Although at this stage of work careful cutting is not essential, a few points should be kept in mind. Moisten the blade so that it will cut cleanly. To cut, hold the knife firmly and at a high angle (24), and draw the tip of the blade lightly across the clay, following the construction line. Complete the slicing in several shallow strokes—not one or two energetic ones. If you cut too quickly, the knife will not only pull clay with it as it exits but may also dig into the plaster bat.

Another way of slicing a slab is with the steel palette. Moisten one edge of the palette and press it down vertically into the slab till the blade meets the bat (25).

24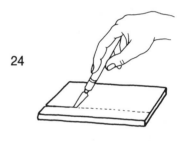

25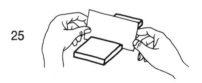

If you are constructing a relatively large piece (say a box 4"x 4"x 6"), the walls, after being cut from the slab, will still be soft enough to sag or even collapse when stood on edge and assembled. Leave these slab walls lying face down on the bat for a short time to stiffen somewhat, but flip the walls over once in a while to dry both sides equally.

*Cutting Segments from a Cylinder*

Place the cylinder on a bat. To cut seg-

ments from a cylinder of clay, place your razor blade on the cylinder (26). Press the blade down slowly while also rolling the cylinder back and forth (27). This method gives clean cuts and will leave the cylinder undistorted.

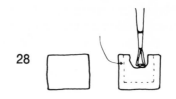

28

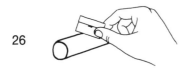

26

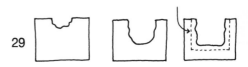

29

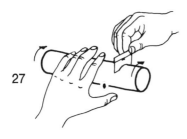

27

## Hollowing Boxes and Vessels

A soft block of clay that is to be carved into a box should be hollowed out in several steps as the piece goes through the stages of drying. The clay can be carved only when sufficiently hard, and since clay hardens gradually, starting from the outside, the hollowing must be gradual. Use a wire-end modeling tool for the initial hollowing. The clay is still relatively soft, so take care not to distort the block by applying pressure near the edges or the bottom (28). Further hollowing is done when the soft clay, freshly exposed, has dried somewhat. The best tool to use for this stage is the plaster chisel. Continue in this way, cutting away in several steps only as much clay as possible before reaching wet clay (29). (Wet clay, like soft butter, cannot be cut without its sticking to the blade.) In the final hollowing stage, when you approach the desired thickness of the wall, the piece should be leather-hard (see Carving Inner Walls, page 29 ).

## Drilling with a Wire-End Tool

You can drill clean holes in clay with a square or round wire-end modeling tool. The size of the hole depends on the size of the tool (30). Place the tool on the clay surface and twist it around slowly while applying light pressure (31). Large openings can be cut with a knife, or by first drilling a small hole and then enlarging the hole with a wire-end tool. For small holes, use the punch method (see next paragraph).

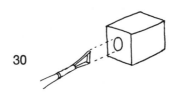

30

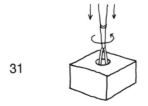

31

## Punching Holes with a Straw

To punch a hole in a clay slab or block, use a drinking straw or any other tube with thin walls. Place the work piece on the bat, hold it down firmly, and push the straw slowly

into the clay (32). Unless the clay is especially moist, you should wet the end of the straw before applying it. If the clay is a bit stiff, twist the straw slowly while pushing it down. Once the straw has reached the bat, lift up the work (33) and push the straw through a little. Then pull it back out, slowly twisting it. If you pull the straw out carelessly, it will not come out straight and the edges of the hole will be ragged. (For punching holes with a straw, the clay has to be relatively soft; in the leather-hard stage you can carve holes. See page 28.)

34
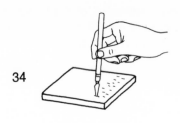

35

32
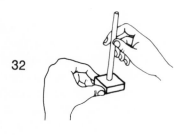

33
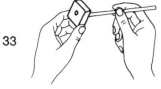

The marks or lines scored should be shallow, in general no deeper than $\frac{1}{16}''$ when working with $\frac{1}{4}''$-thick slabs.

(When attaching tiny pieces—for example, eye pellets on a small figurine—you don't need to score. Just make a depression to receive the pellet, apply slip, and attach the pellet with slight pressure.)

*How to Apply Slip*

Slip is generously applied with a brush on *both* surfaces to be joined (36, 37).

36
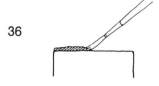

37
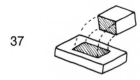

### Joining

*Scoring*

All surfaces to be joined must be roughened so that they will adhere properly. This procedure is called *scoring* and can be done in at least two ways:

1. Jab the surface with the tip of a slanted knife or other sharp, pointed instrument (34).

2. Cross-hatch the surface with knife cuts (35).

*Pressing Parts Together*

Once you have prepared the surfaces to be joined by scoring and applying slip, assemble the various parts. Press together the

newly joined parts so that the seams are tightly closed (38, 39). Use a wooden modeling tool to blend all the seams, both outside and inside (40).

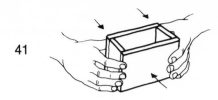

41

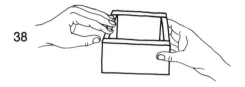

38

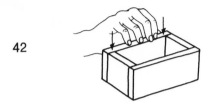

42

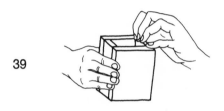

39

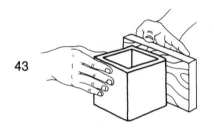

43

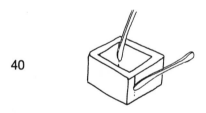

40

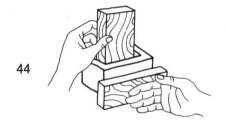

44

## Post-Assembly Work

Since clay at this stage is still relatively soft, the pieces you have joined will sometimes separate, bend, or sag. Close any seams that have come apart (41, 42). To straighten sides, use your hands and, especially where hands cannot fit, flat pieces of wood (43, 44). Fill gaps or open seams with thin clay coils or tiny pellets and blend in well with a wooden modeling tool (45). Any other cavity or uneven surface can be filled and smoothed at this time.

45

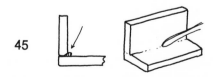

### Problems in Joining Parts

If seams come apart as the piece is drying, the clay must have been too dry at the time of joining. Be sure to join clay parts while they are still in the plastic stage. (If the parts are not moist enough, they will absorb the moisture from the slip and leave it too dry to act as an adhesive.)

Joints will also split if the clay parts joined are not equally moist. The difference in water content will cause one part to dry and shrink sooner than the other one.

### First Drying Stage

Care in drying the clay is a fundamental part of making clay sculpture. Although you don't actively work on the clay at this stage, the clay is doing work of its own: drying. And as it dries, it always shrinks slightly. The problem with shrinkage is that if different parts of a clay construction dry at different rates (for example, if one part is covered and the other is not), then they will shrink at different rates too, resulting in a warp or a split joint.

To avoid warping and splitting, dry the piece at a slow, controlled rate. Place the piece in a covered container or a plastic bag, or cover it with plastic wrap. Since you do want the clay to lose moisture, you should keep the cover or wrap slightly open to allow for air exchange. To allow the bottom of the piece to dry, keep the piece standing on balsa strips (46). On especially warm and humid summer days, pieces can go through the first drying stage with no covering at all, provided they are small and not made of many parts joined together.

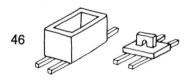

46

The first drying stage allows the piece to lose moisture slowly and ensures that no part of the piece dries unreasonably faster than other parts. When the clay is leather-hard, the first drying stage is finished and the piece is ready for carving. Pieces that need no more work can, of course, be left to dry completely.

Since drying time varies with the temperature and humidity of the air, with the size and shape of the piece, and with the method of drying, only rough figures can be given here. A box 3″x 2″x 2″, made from ¼″ slabs, will dry to the leather-hard stage in three to four hours if left uncovered on an average day.

A problem can occasionally show up even under controlled drying. Sometimes a joint will split apart (47). The reason for this could be that the parts were too dry when joined, that the joined surfaces weren't properly scored, that enough slip wasn't applied, or that the rate of drying was too fast. When this happens, the piece is lost, but you can reclaim the clay (see page 9 ).

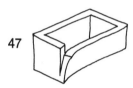

47

### Cutting and Carving Leather-Hard Clay
*Tools*

The tools used for cutting and carving are an X-acto knife, a razor blade, a plaster chisel, and a wire-end modeling tool. Each performs its own particular service well and efficiently and should be used only for that purpose. The choice is usually obvious, since the hardness, size, and accessibility of the piece being worked on and the kind of cut needed determine what tool will be used.

The following list provides a general description of the uses of the tools:

    X-acto knife: For slicing small sections out of a block; planing or cutting surfaces not accessible to razor blade.

Razor blade: For slicing large sections out of a block; planing large, open surfaces.

Plaster chisel: For planing surfaces not easily accessible; finishing the inner wall surface of boxes; impressing guidelines in leather-hard clay; carving hard, though not bone-hard, clay.

Wire-end modeling tool: For planing the inside floor of boxes; drilling holes; cannot actually cut leather-hard clay.

Before you make a cut, it is best to moisten the blade for better lubrication. Dip the blade in water and wipe it almost dry, leaving only a thin film of water. Always clean the blade of any clay stuck on it after a few cuts. If you don't the clay residue will dry on the knife and mar the surfaces you cut.

The small shreds of clay produced while planing and cutting are still soft, and they tend to adhere to their parent block. They are best removed by dusting with a dry brush. Trying to pick the shreds off with any other tool only makes them stick more.

The clay will soon wear down the cutting edges of your tools, so change or resharpen them when they become dull. Your work will suffer if you use a dull blade.

*Cutting Methods*

Here are the most typical cuts you will perform on leather-hard clay:

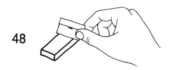

*Slicing Blocks:* For slicing, turn the clay so that the cut is directed downward. Place the blade in position (48), and with slight pressure push it into the clay until it will stay in place without being held (49). Check and correct the angle of the blade. Then push the blade down using both hands (50). Apply only enough pressure to keep the

blade moving slowly; quick motions can deflect the blade.

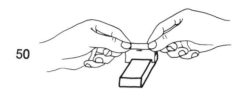

When the length of the cut is longer than the width of the blade, more than one cut is necessary (51).

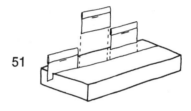

*Cutting Decorative Details:* To cut facial features, handles, and notches or similar smaller details (52), use a blade or a knife on outside surfaces and a knife on inside surfaces (53). A support counteracting the force and direction of the cut is often necessary to prevent the clay appendage, such as an animal head, from breaking off.

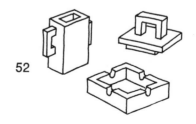

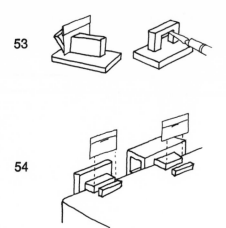

53

54

In order to plane, take a blade and find the angle at which it will cut a thin slice from the clay surface. Then take off thin slices until the desired level is reached (57). When planing the top surfaces of the walls of a box, it is difficult to keep all four sides equally high; it is best to mark a guideline first all around the box that is parallel to the bottom edge (58).

57

Support can be provided by the work surface or your fingers. For outside cuts, use the downward slicing method already discussed, but make sure that you lay the part being cut on a support. Illustration 54 shows two typical cases: both the lid handle and the ear are supported on some work surface.

*Planing:* Planing means slicing thin layers off a surface either to uniformly lower a surface or to even it out. In the woodworking plane, the blade is rigidly fixed at some angle relative to the work surface. In clayworking, where the blade is hand-held, it is important to give the blade some rigidity by holding it firmly. When possible, you can also butt the index finger against an adjacent side of the piece as you move the blade along (55, 56).

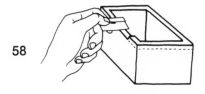

58

When planing a flat surface, especially the top surfaces of walls, direct the blade inward, away from the edge (59). Cutting toward the edge results in chipping (60).

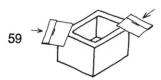

59

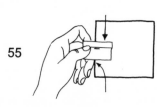

55

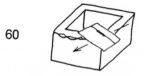

60

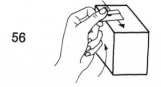

56

Cylindrical surfaces can be planed with a blade, but this is a troublesome procedure because the blade is likely to slice too deeply into the clay. It is better to plane

such pieces in the soft, plastic stage by burnishing with a wooden modeling tool or by scraping with a wire modeling tool.

*Cutting Grooves and Channels:* To cut grooves or channels, mark out guidelines (61), then cut the vertical sides with a blade (as in slicing—see page 25) (62). With a tilted blade, cut out the waste clay in the form of wedges (63). Finally, clean the bottom of the groove with a wire-end modeling tool (64).

Cutting deep channels is an easy method for adding legs to clay pieces. To cut four legs (65), mark the clay as shown and cut *two* grooves (66). (More under Adding Legs, page 93.)

65

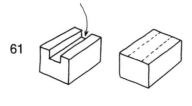

61

66

62

To produce thin and shallow grooves, make two cuts with the blade, removing a narrow wedge of waste clay (67).

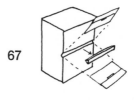

67

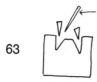

63

64

*Cutting from Slabs:* To cut figures and various shapes out of a slab (68), first draw the guidelines with a toothpick or other tool (69). For curved lines, use a knife (70). For straight lines, either use a blade to slice off the unwanted part, or use a knife to cut through the slab with several shallow passes (71). For best results, lightly wet the tool blade before applying it to the clay.

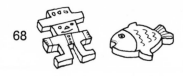

68

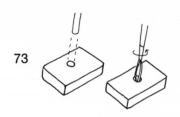

73

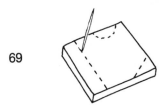

69

To produce shallow rectangular depressions, such as on the bottom of boxes and for lid collars (74), mark deep furrows into the clay with a chisel, knife, or blade. Then clean out the waste with the plaster chisel or wire-end tool (75).

On larger pieces the cutting of such depressions is functional because the weight of the piece is reduced, but for small pieces such cutting is mostly for aesthetic interest.

In the case of slabs used as wall decoration, a hollowed back provides a "hook" for hanging the piece up.

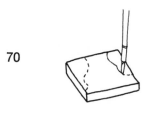

70

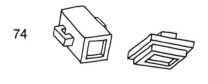

74

71

75

*Cutting Shallow Depressions:* Small and shallow circular depressions, such as eyes for a mask (72), can be made by pressing a straw or other tube into the clay to the required depth. After carefully pulling the straw out, the clay within the circumference can be scooped out with a miniature wire-end tool or substitute (73).

*Carving Fine Details:* The carving of fine details is best done with the tip of the X-acto knife. The facial features of a mask and the teeth of an animal head are common examples of such carving (76). To steady the tool, hold the work in one hand and support the tool-using hand either on the bat surface, table, and so on (77), or against the hand holding the work (78). Hold the knife as if it were a pencil.

72

76

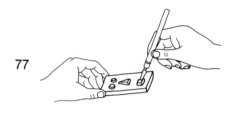

77

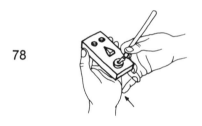

78

*Carving Inner Walls:* Containers built from slabs, whether square or round, will need no special work on the walls. However, when you want to make a container from a single block of clay, the carving of the inner walls needs some attention. (Most of the cavity will already have been hollowed out. See Hollowing Boxes and Vessels, page 21.) When you are about to carve the walls down to their final thickness, follow these steps:

*Square Containers*

a. Mark out the guidelines indicating the thickness of the wall (79).

b. Press the plaster chisel about 1/16" into the clay, then pull it up and press it down again beside the first blade impression. Repeat this procedure along the entire length of the guidelines, producing a continuous and thin but relatively deep furrow (80).

c. Plane with the chisel most of the excess clay well inside of the guidelines (81). Then, still using the chisel, carefully carve away the remaining waste clay along the guidelines (82).

*Round Containers*

Wet the inside of the wall all around with water to make the surface of the clay more pliable, and then smooth the wall with either a wire-end or a wooden modeling tool.

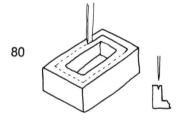

79

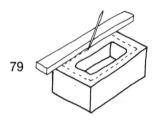

80

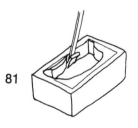

81

82

*Fitting Lid Collars:* Without a lid collar, a lid would easily slide off the top of its container. When first attached to the lid, the collar should be slightly too large to fit into the container. The excess clay is cut off the collar in the leather-hard stage. To know where and how much to cut, place the lid on the container, well centered, and examine the situation by eye (83). Once you have roughly trimmed away most of the obvious excess, proceed more slowly, cutting thin slices away, and checking for fit after each cut (84). If you have any trouble fitting the lid by this method, another one is available. Wet the edge of the collar till it is soft enough to take a light impression, and then press the lid (well centered) on the container. The resulting impression will show where to cut (85).

possible to wet it again and do corrective work or minor alterations on a piece even after it is completely dry.

To fill up depressions, moisten the area in question with a brush and score the softened clay. Be sure to wet the surrounding area as well (86). Repeat until enough water has penetrated the area, making it plastic once more. Fill the depressions with clay that is as moist as the area to be repaired (87). Once the added clay is leather-hard, the excess can be planed off (88).

To eliminate raised irregularities, moisten the particular area with water (89), and plane, cut, or scrape away the excess clay (90).

If you want to add new parts to a dry piece, you can use white glue to join them.

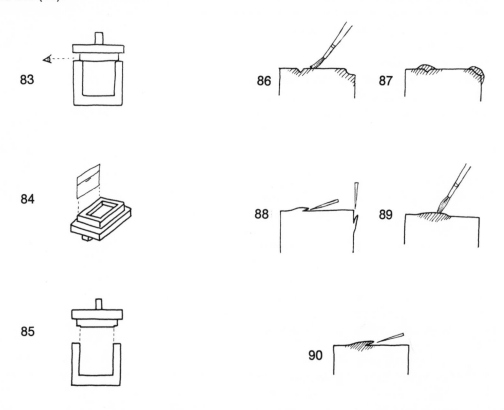

**Corrections after Piece Is Thoroughly Dry**
Since unfired, self-hardening clay needs a special coating to make it waterproof, it is

# 5. Decorative Finishes

**Decoration Using Clay**

(pre-paint/glaze decoration)

Clay pieces can be decorated in many ways before colors or glazes are applied.

*Impressions*

The tools for making impressions were discussed in the chapter on tools and materials. With this method, the decorative work on a clay piece begins when the clay is in the plastic stage. Many kinds of pieces can be created where an impressed design is the main decorative feature. Such a piece can be finished simply by adding a glaze. Fine details in impressions tend to become filled up by thick and opaque paints.

*Applied or Relief Ornaments*

You can attach a shape cut from a slab to a clay piece either by joining it in the soft stage with scoring and slip or by gluing the ornament onto the piece after both are dry. In the first method you can carefully join the precut ornament so as not to distort its shape, or else you can attach without any special care a roughly cut slab ornament somewhat bigger than the final size planned, and, when it is leather-hard, carve the ornament to the desired form (1). If you prefer gluing (2), you can use white PVA glue. Wipe off any excess glue, using a small, wound-up roll of facial tissue, the end of which has been dipped in water.

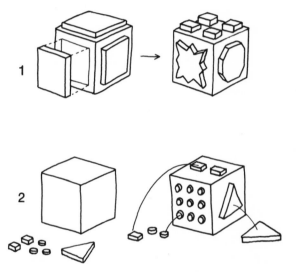

*Covering with Slip*

Brushing slip on the surface of a clay piece gives the piece a uniform, matte finish that is light in color and has a pleasantly rough touch. Care must be taken not to apply slip to surfaces that require a close fit (e.g., lid collars and wall surfaces in contact with them). Brushing slip on a surface can quickly raise its level.

*Sgraffito*

If you cover a clay piece of one color with slip of another, preferably contrasting, color, then, by scratching away the dried slip, you can expose the clay color under it.

Using a knife to scratch lines, and the plaster chisel (or a razor blade) for scraping broader areas, you can create a design in two colors (3).

## Glazing and Painting

Painting and glazing are best done with a fine-haired, wide brush, such as a 3/8″ camel's-hair brush. To cover larger pieces more quickly, a wider one can be used. For finer detail, pointed camel's-hair or sable brushes do best. If you like using spray-can paints and glazes, you can certainly try these out.

Both paints and glazes should be applied in several thin coats, rather than in one thick layer. Three or four coats are enough, but glazing can be done many more times. The more layers of glaze, the deeper the glasslike finish becomes.

It is important not to paint or glaze the sides of lid collars, and the walls in contact with these, in boxes and containers that have tight-fitting lids. Where enough room permits, coating these surfaces creates no problem with fit.

Both paints and glazes fall into two categories: water-base and non-water-base (synthetic lacquers, dyes). The first type is easy to handle and clean up because it is water-soluble and has no offensive vapors. The second type requires special solvents (such as acetone, turpentine, or alcohol) to clean brushes and should be used only with adequate ventilation. The advantages are that this type dries faster and is considerably harder than its water-base counterpart.

If a piece is finished with a non-water-base paint, then no additional waterproofing is needed. The application of a glaze at this point is only for appearance. A piece finished with a water-base paint must be glazed in order to seal the surface from moisture and dirt.

Acrylic polymer paints and glazes and egg tempera stand somewhere in the middle; these media are water-soluble but become impermeable to water once dry.

*Unpainted Finish with Glaze*

If you find the texture and tone of dry clay attractive, you need not put any additional finish on your completed piece. Note, however, that dried clay pieces are often slightly irregular and mottled in tone. A lump of clay left unworked will dry with a uniform, darker tone, except that its bottom will be lighter. But once you work the surfaces of the clay, differences in tone can appear. In areas where some portion or surface of the clay was cut, smoothed, covered with slip (squeezed out of joints), or in contact with (or at least very close to) the bat during drying, the clay will appear lighter than it would if left alone to dry.

Pieces on which you have uniformly worked all surfaces (i.e., cut, smoothed, covered with slip, and so on) will have a homogenous surface appearance. Smoothing a piece can be done when the clay is still soft, when it is leather-hard, and even when it is dry, provided you rewet the surfaces enough to be workable. In each case you can use a wooden modeling tool or your fingers.

But since unfired clay remains vulnerable to moisture, it is a good idea to waterproof the piece by coating it with a transparent glaze. This coating darkens the clay color somewhat, but gives the piece a more even-toned, glossy or matte surface sheen.

Before applying the glaze, any grease on the clay surface should be cleaned off by rubbing lightly with extra-fine sandpaper.

*Glazes*

*Water-Base*

1. *Acrylic Polymer Medium:* This medium, available glossy or matte, is waterproof but not very hard once dry. Follow

instructions given with the product. Thin the medium with water, about 3 parts medium to 1 part water.

2. *Egg Tempera:* To make egg tempera, break an egg carefully, keeping the yolk intact. Pass the yolk from half shell to half shell until the white has drained. Remove the white cords that connected the yolk and shell. Break the yolk into a container, add about 2 teaspoons water, and mix. The egg tempera glaze can now be applied. Keep the brush wet while waiting for coats to dry; dried egg is not water-soluble.

*Non-Water Base*

1. *Clear Nail Polish:* This is a synthetic lacquer. Apply several thin coats. Nail polish quickly dries to a waterproof and hard finish.

2. *Clear Della Robbia Glaze:* Another hard, synthetic lacquer with very strong fumes. Dries more slowly than nail polish.

3. *Varnish and Shellac:* These two finishes dry waterproof and hard but much more slowly than all the others.

*Painted Finish with or without Glaze*

Painting your clay pieces opens up a great many ways to enhance the appearance of your work. There are two basic alternatives to choose from: monochrome or polychrome finish (4). Once you have decided on your colors and designs, clean the piece with extra-fine sandpaper, then paint the piece and, when the paint is thoroughly dry, apply the glaze.

4

## Colors

*Water-Base Colors*

1. *Poster Colors:* These are probably the simplest to use, and, because they are opaque and cover evenly, they give a professional appearance to your work. They are also easily available and can be mixed to provide an endless variety of colors.

2. *Felt-Tip Markers:* A wide-tipped marker covers better than a pointed one, but if you use the flat side of the tip, the pointed kind can do. The coloring materials in these markers are not pigment paints but transparent dyes. They have considerable tinting strength, but the clay color will show through the light- and medium-tone dyes. One drawback of both water-base and non-water-base markers is that if you apply more than one coat, the previously applied coat can dissolve again, giving the piece a streaky finish. The darker dyes—for example, dark blue or black—will, of course, completely cover the color of the clay.

3. *Acrylic Polymer Colors:* These are not as opaque as poster colors, and therefore more coats are needed. A great number of colors are available and can be mixed.

*Non-Water-Base Colors*

1. *Nail Polish:* The range of colors in this medium is nowadays great enough to recommend it. The ease of application and rapid drying time are also attractive features.

2. *Felt-Tip Markers:* The comments on water-base markers apply here also. The non-water-base kind comes in many more colors than the first kind. Mixing colors is not practical.

3. *Della Robbia Colors:* These strong-fumed colors are intermixable and provide the ground color over which glaze can be applied. The colors are semiglossy and can remain unglazed. A special undercoat seal must be applied before using these colored glazes. Instructions supplied with the product should be followed.

## Details on Painting

*Designing on Clay*

Simple geometric or nature designs, especially if done with quick, spontaneous brushwork in the Oriental style of painting, can be done freehand. First cover the entire surface with the basic tone color, and, when dry, paint the design on top of this color (5).

Regular geometric, repeating, and symmetrical designs should be drawn on the clay before paint is applied. To copy a drawing onto clay, you can use the same methods used to copy onto paper. Trace your master design onto tracing paper, then shade with pencil the reverse side of the tracing paper. Lay the paper, with the drawing on the top side, on the clay surface, and go over the lines with a pencil or a pen to impress the design (6). Once the design is on the clay, fill in each area with the color you have chosen for it. If you need to reduce or enlarge a design to proper size, draw a grid over the original design and enlarge (or reduce) by copying design onto grid of desired size (7).

7

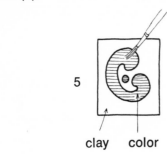

5

clay    color

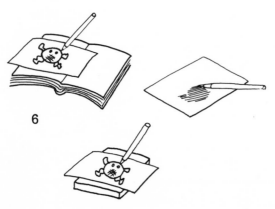

6

*Monochrome*

Painting a clay piece in one color only, followed by a transparent glaze, can give attractive and elegant results.

If you paint with one color, you can still produce a design in two colors simply by leaving the clay unpainted in certain areas. Try to choose a paint that contrasts well with the color of the clay. As an example, terracotta clay would go well with black paint (cf., ancient Greek painted pottery) and other darker colors, whereas if you use a medium-light or light color, such as leaf green, pink, or ocher, the piece will lack visual strength. But even such pieces can be rescued if you add dark outlines.

*Polychrome*

In polychrome painting, just as in painting with one color, areas of unpainted clay can again act as one of the colors in the design. In fact, contrary to one's instincts, the less color that appears on a piece, the more colorful is its overall look.

# 6. Projects: Section I

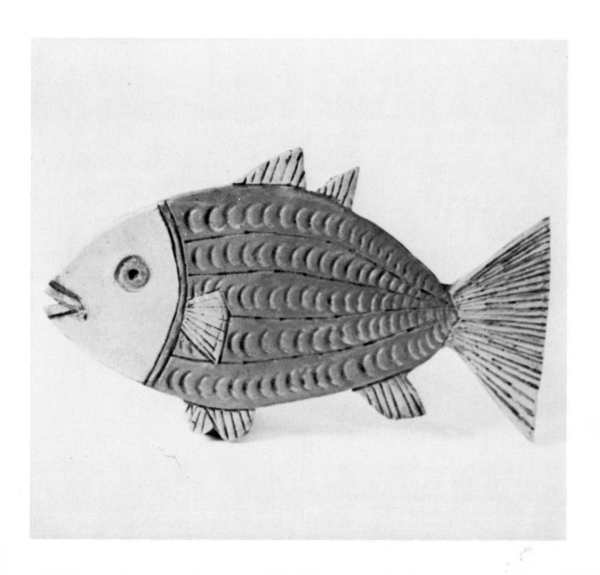

## Box with Lid
The construction of this piece involves practically all major methods used in all the pieces in this book (using slabs, joining, and carving). And since the box is such an essential component of a great class of decorative and useful objects, building this project is almost like taking a basic course. *Remember that all the measurements are given in units, not inches.*

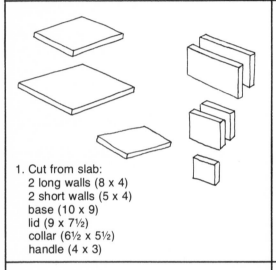

1. Cut from slab:
   2 long walls (8 x 4)
   2 short walls (5 x 4)
   base (10 x 9)
   lid (9 x 7½)
   collar (6½ x 5½)
   handle (4 x 3)

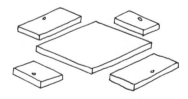

2. Lay down the 4 walls around the base. (Make sure that the longer side of each wall is adjacent to the base.) Make small punchmarks with a toothpick as indicated. (The marks will prevent confusing the various wall surfaces.)

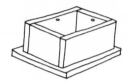

3. Assemble the walls on the base, keeping the toothpick marks on the inner surfaces at the top.

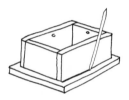

4. Use a toothpick to draw an outline on the base both outside and inside the box.

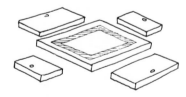

5. Take the box apart, laying down the sides. Score the strip outlined on the base.

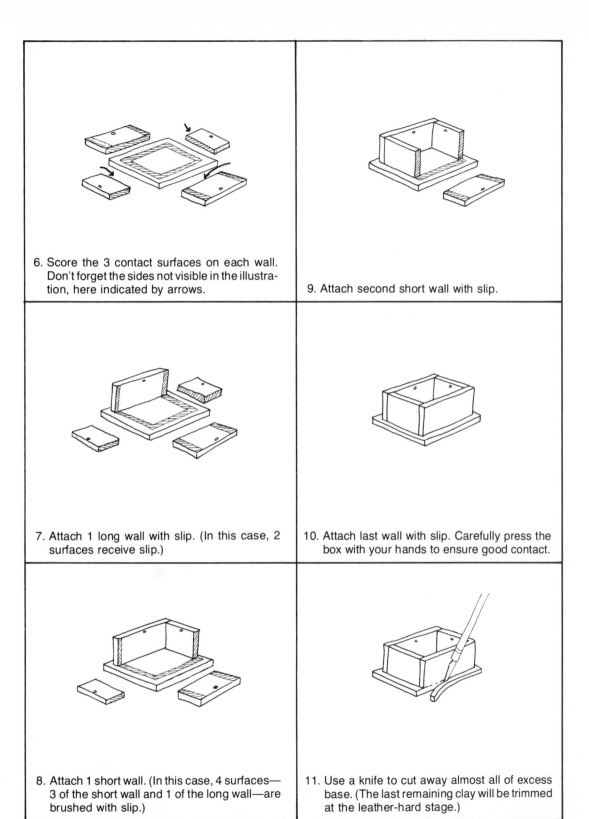

6. Score the 3 contact surfaces on each wall. Don't forget the sides not visible in the illustration, here indicated by arrows.

7. Attach 1 long wall with slip. (In this case, 2 surfaces receive slip.)

8. Attach 1 short wall. (In this case, 4 surfaces— 3 of the short wall and 1 of the long wall—are brushed with slip.)

9. Attach second short wall with slip.

10. Attach last wall with slip. Carefully press the box with your hands to ensure good contact.

11. Use a knife to cut away almost all of excess base. (The last remaining clay will be trimmed at the leather-hard stage.)

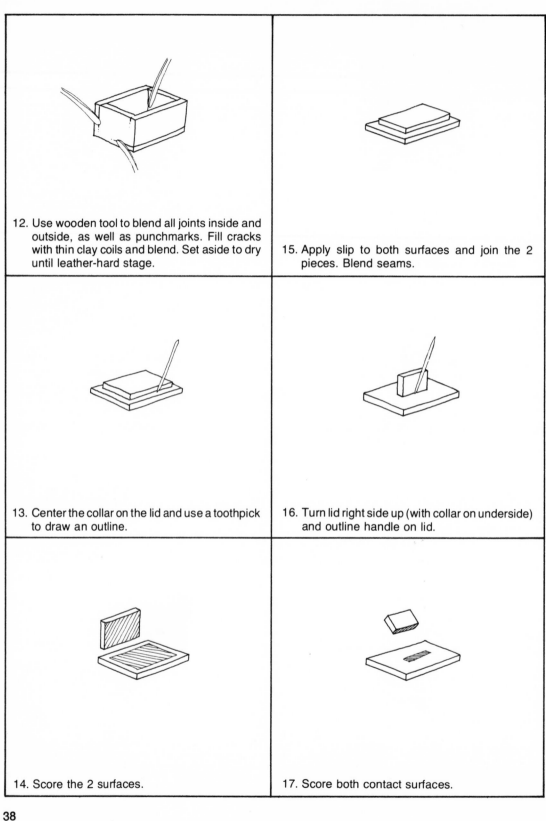

12. Use wooden tool to blend all joints inside and outside, as well as punchmarks. Fill cracks with thin clay coils and blend. Set aside to dry until leather-hard stage.

13. Center the collar on the lid and use a toothpick to draw an outline.

14. Score the 2 surfaces.

15. Apply slip to both surfaces and join the 2 pieces. Blend seams.

16. Turn lid right side up (with collar on underside) and outline handle on lid.

17. Score both contact surfaces.

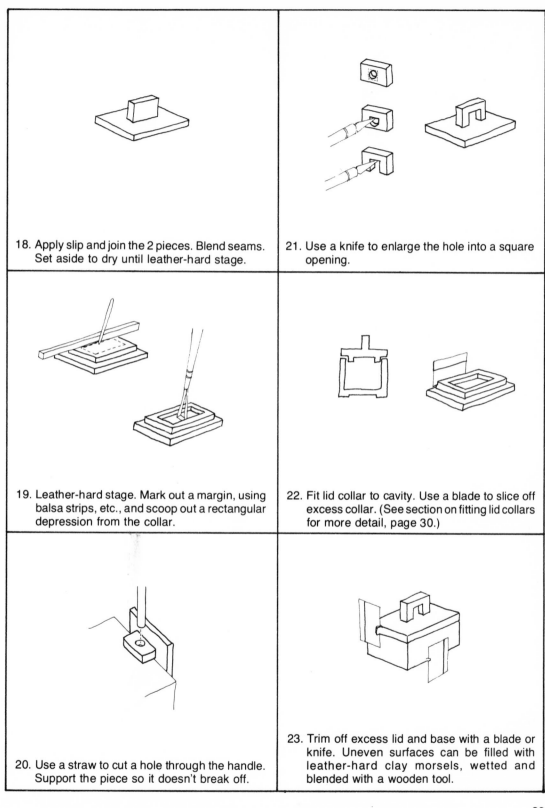

18. Apply slip and join the 2 pieces. Blend seams. Set aside to dry until leather-hard stage.

19. Leather-hard stage. Mark out a margin, using balsa strips, etc., and scoop out a rectangular depression from the collar.

20. Use a straw to cut a hole through the handle. Support the piece so it doesn't break off.

21. Use a knife to enlarge the hole into a square opening.

22. Fit lid collar to cavity. Use a blade to slice off excess collar. (See section on fitting lid collars for more detail, page 30.)

23. Trim off excess lid and base with a blade or knife. Uneven surfaces can be filled with leather-hard clay morsels, wetted and blended with a wooden tool.

## Round Container

This project, which consists of a round wall and a base slab, illustrates a simple basic way of building low-walled cylindrical containers.

1. Cut a slab (35 x 7) for the wall of the container and bend it into a circle.

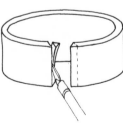

2. Use a knife to cut off a wedge from each end. The newly cut, slanted faces should be parallel.

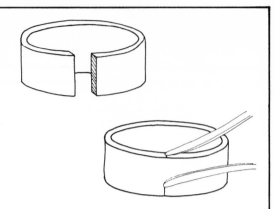

3. Score the 2 surfaces you just cut. Apply slip and join the wall. Use a wooden tool to blend the seams both outside and inside.

4. Turn the wall around between your fingers to correct distortions.

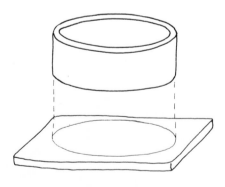

5. Cut a slab larger than the container wall.

6. Outline the wall on the slab, both inside and outside.

7. Score the 2 surfaces, apply slip, and join wall to slab.

8. Cut away most of the excess slab, but leave a narrow ledge of clay, which you will cut off later on.

9. Use a wooden tool to blend seams, inside and outside. Set aside to dry until leather-hard stage.

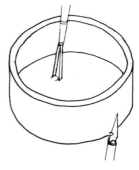

10. Leather-hard stage. Use a knife to cut base flush with wall. Use flat-ended wire-end tool to flatten floor of container. Fill crevices and depressions with leather-hard clay scraps slightly moistened. Blend these in with a wooden modeling tool.

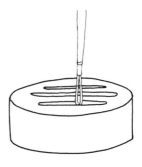

11. Cut a few shallow grooves on the bottom with a small round-ended wire-end tool.

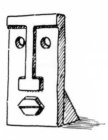

## Slab Mask

This mask is put together using only slabs. It includes all basic facial features. You can use this construction to create many different masks by varying the proportions of the mask, and by omitting, adding, and/or changing the relative sizes of parts.

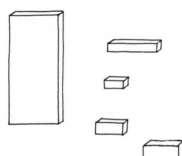

1. From a slab, cut 6 pieces:
   face (12 x 8)
   brow (8 x 1)
   nostril piece (3 x 1)
   nose (6 x 1)
   mouth (4 x 1)
   support slab (4 x 4)

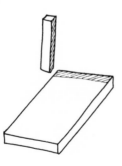

2. Score the brow and the corresponding area on the top of the face. Apply slip and attach brow.

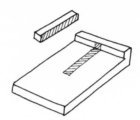

3. Score 2 surfaces of the nose (1 side is hidden in the drawing) and the corresponding ones on face and brow. Apply slip and attach nose.

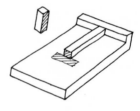

4. Attach the nostril piece after scoring the 4 contact surfaces and applying slip.

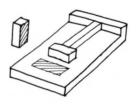

5. Score the 2 contact surfaces, apply slip, and attach the mouth.

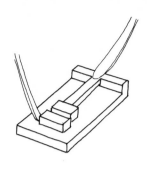

6. Use a wooden tool to blend all seams.

9. Dry mask to leather-hard stage face down.

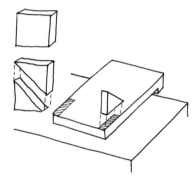

7. Cut the support slab diagonally. Each triangle will be attached to the bottom of the reverse side of the mask.

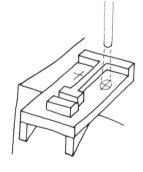

10. Leather-hard stage. Mark out the positions of the eyes and punch eyeholes with a straw (see "Cutting Shallow Depressions," page 28).

8. Score the 4 contact surfaces, apply slip, and attach supports.

11. Draw a line dividing the mouth in half.

12. In order to cut a groove into the mouth, first press the blade in at an angle.

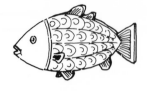

## Fish Slab

This piece represents the construction of a typical ornamental slab used as wall decoration. It requires little technique aside from cutting and impressing a slab, but still gives handsome results.

13. Next, make a second cut from the opposing angle. The result should be a triangular channel.

1. Divide a piece of paper in half and draw a diamond centered on the fold. If the fish is to be 4″ long or less, make the slab 1 unit thick; if the fish is to be up to 6″ or 7″ long, make the slabs 2 units thick.

14. *Optional:* cut the corners of the mouth with a blade.

2. Round out the diamond.

3. Add tail and fins. Cut out the paper pattern.

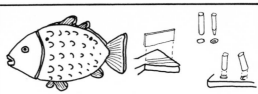

6. Refine contour. Details can now be impressed. For fin and tail rays, use a thin-edged instrument. The gill and the mouth lines can be impressed using either round-edged objects or a plaster chisel. In the second case, the curved lines are approximated with short, straight line segments placed side by side. The eyes appear best with 2 concentric circular impressions. To mold the scales, you can use dowels or coins held at an angle. The mouth opening can be carved or punched with a straw.

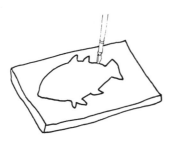

4. Cut slab, using pattern (see "Measurement and Layout—Slabs," page 19). Set slab aside till it's firm enough to be picked up.

5. Punch 2 holes for hanging slab on wall later (or choose some other method from section on wall hangings, page 92).

Fish can be designed from simple geometric figures. Besides the oval used in our construction above, you can start with a square, a rectangle, a diamond, or a circle.

In nature, fish come in a great variety of forms, and all show perfection in design. The major representative types of fish are illustrated below.

Trout

Pike

Needlefish

Hatchetfish

Halibut

Stickleback

Swordfish

Sea Horse

Harvest Fish

Barracuda

Moonfish

Tuna

Bass

Marlin

Angelfish

## Block Container

The construction of this project employs the simple method of building a container by pushing a hole into a lump of clay and then cutting straight sides.

3. Use a steel palette to mark out a square around the hole. Cut off the clay outside the square, using a steel palette.

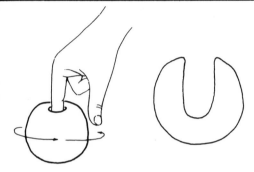

1. Take a lump of clay about the size of a lemon and press your index finger down into the center of the ball while twisting the ball around with the other hand. Keep your drilling finger straight. The hole should not go too close to the bottom.

4. Use a wooden tool to smooth both the inside and the outside walls. Set aside to dry until leather-hard stage.

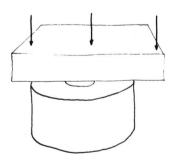

2. Flatten the top of the lump with a board.

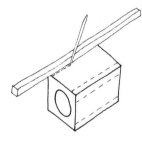

5. Use a ¼" balsa strip to mark out 2 guidelines on each long side.

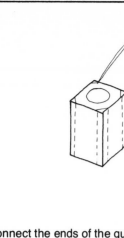

6. Connect the ends of the guidelines with lines drawn on the top and the bottom surfaces.

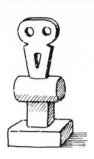

**Figurine**
This elegant African design combines only a few parts (2 blocks, a cylinder, and a slab), yet it is monumental in appearance and is impressive whether built as a small figurine or as a larger statue.

7. Use a blade to cut the beveled edges, following the guidelines you have drawn. It is better to finish the cut in several shallow passes than to try to do it with a single slice.

1. Prepare:
   1 block (3½ x 3 x 2)
   1 base (8 x 4½ x 3)
   1 cylinder (6 x 3)

   Then cut from slab:
   1 face (8 x 6)

8. *Optional:* You can further ornament the piece by beveling the remaining edges on both top and bottom. You can also hollow a depression on the bottom.

2. Center the block on the base and outline it with a toothpick.

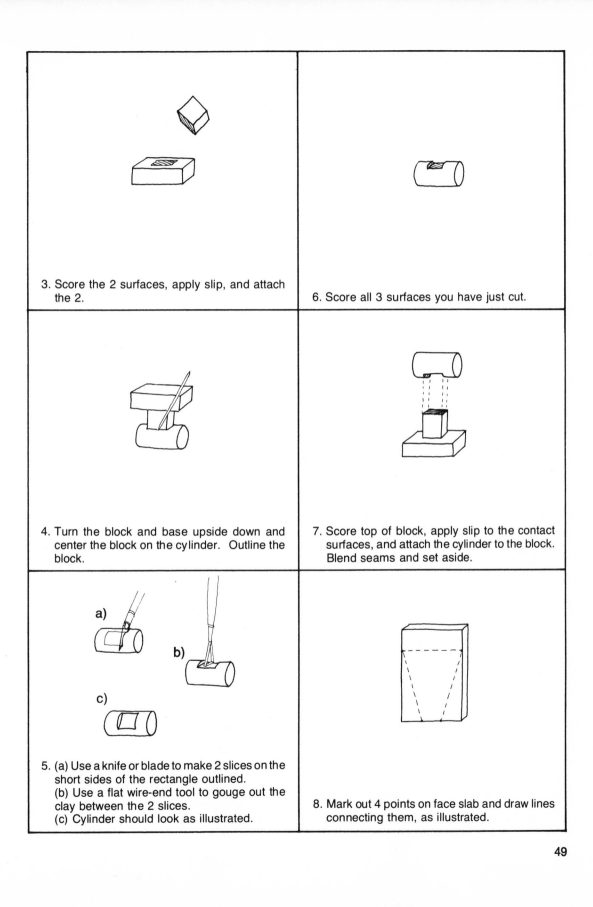

3. Score the 2 surfaces, apply slip, and attach the 2.

6. Score all 3 surfaces you have just cut.

4. Turn the block and base upside down and center the block on the cylinder. Outline the block.

7. Score top of block, apply slip to the contact surfaces, and attach the cylinder to the block. Blend seams and set aside.

5. (a) Use a knife or blade to make 2 slices on the short sides of the rectangle outlined.
(b) Use a flat wire-end tool to gouge out the clay between the 2 slices.
(c) Cylinder should look as illustrated.

a)

b)

c)

8. Mark out 4 points on face slab and draw lines connecting them, as illustrated.

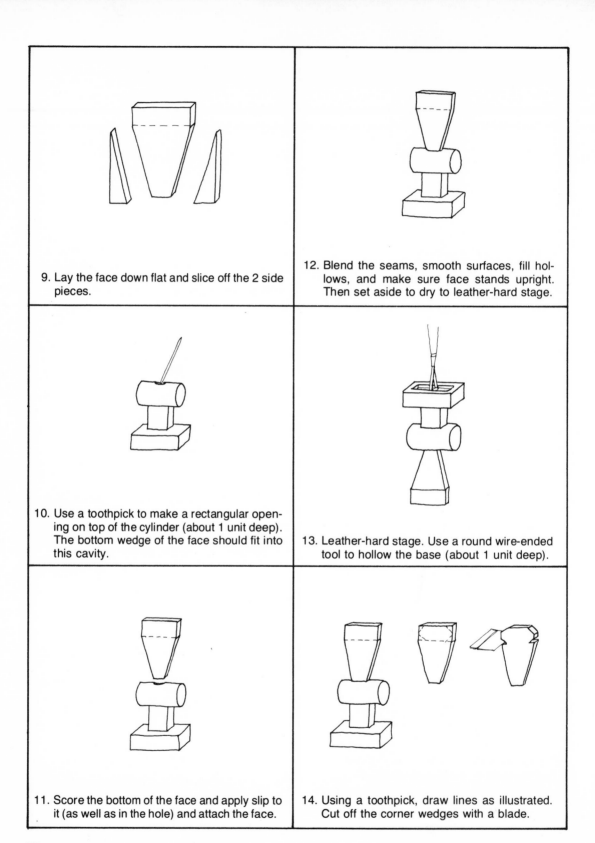

9. Lay the face down flat and slice off the 2 side pieces.

12. Blend the seams, smooth surfaces, fill hollows, and make sure face stands upright. Then set aside to dry to leather-hard stage.

10. Use a toothpick to make a rectangular opening on top of the cylinder (about 1 unit deep). The bottom wedge of the face should fit into this cavity.

13. Leather-hard stage. Use a round wire-ended tool to hollow the base (about 1 unit deep).

11. Score the bottom of the face and apply slip to it (as well as in the hole) and attach the face.

14. Using a toothpick, draw lines as illustrated. Cut off the corner wedges with a blade.

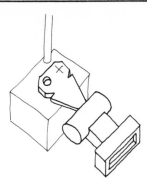

15. Mark out centers for eyes. Use a straw to punch out the eyes. It is important to punch against a support because the head can easily come off.

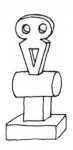

18. Use a knife or blade to plane uneven surfaces. Fill up depressions with moistened leather-hard clay scraps and blend with a wooden tool. If you like, you can round off the sharp corners by carving, and you can also bevel the edges.

16. Mark out a triangle, as shown.

**Figure with Urn**
This is an African design, slightly modified; originally the legs were flat on the base. It is easy and gratifying to build. Depending on what size you build the piece, the urn can serve as a receptacle for toothpicks, cigarettes, pencils, and so on.

17. Use a knife to cut out the triangle you have just marked.

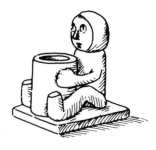

1. Cut 2 slabs for the urn (17½ x 6½) and base (12 x 9). Then make a cylinder for the body (6½ x 3).

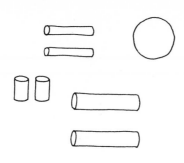

2. Make a ball for the head (5 units in diameter).
   Form 3 pairs of cylinders:
   2 arms (7½ x 1½)
   2 legs (8½ x 2)
   2 feet (3 x 2)

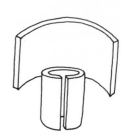

5. Bend the urn slab into a cylinder.

3. Place the body cylinder on the base, about 1
   unit from the edge and centered on the long
   axis. Use a toothpick to outline the body on
   the base.

6. Use a knife to cut a triangular wedge off each
   edge. (This gives you a greater adhesion sur-
   face and also makes it easier to press edges
   against each other.) Score, apply slip, and
   join. Blend seams both inside and outside
   with wooden tool.

4. Score the 2 contact surfaces, apply slip to
   scored surfaces, and join the 2 pieces. Blend
   seams with wooden tool.

7. Place the urn on the base about 1 unit from
   the body, centered on the long axis, and use a
   toothpick to outline the urn on the base.

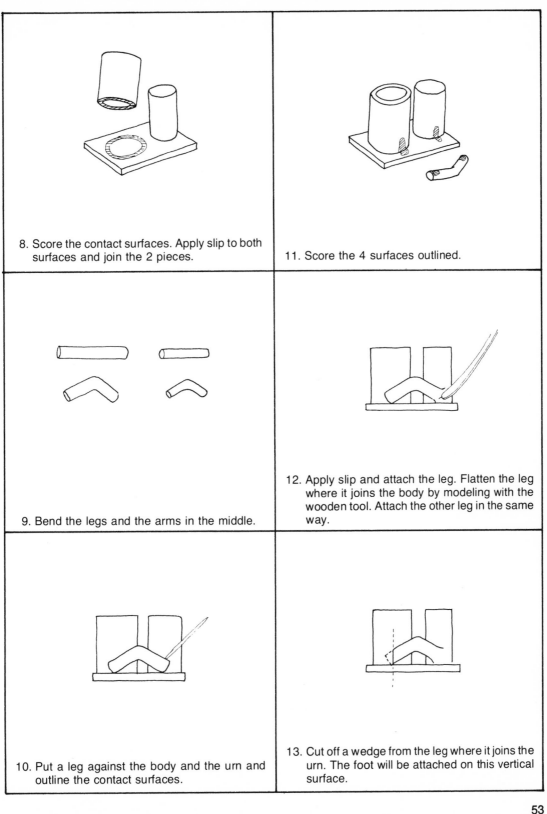

8. Score the contact surfaces. Apply slip to both surfaces and join the 2 pieces.

11. Score the 4 surfaces outlined.

9. Bend the legs and the arms in the middle.

12. Apply slip and attach the leg. Flatten the leg where it joins the body by modeling with the wooden tool. Attach the other leg in the same way.

10. Put a leg against the body and the urn and outline the contact surfaces.

13. Cut off a wedge from the leg where it joins the urn. The foot will be attached on this vertical surface.

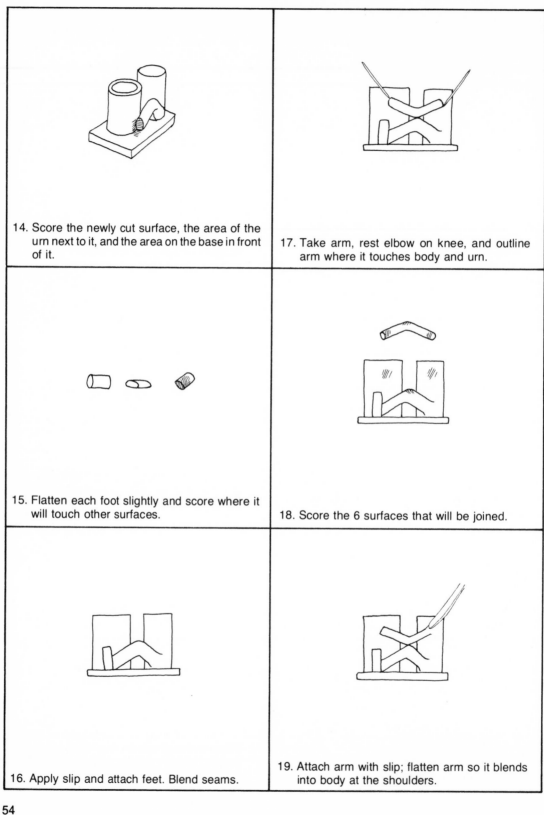

14. Score the newly cut surface, the area of the urn next to it, and the area on the base in front of it.

17. Take arm, rest elbow on knee, and outline arm where it touches body and urn.

15. Flatten each foot slightly and score where it will touch other surfaces.

18. Score the 6 surfaces that will be joined.

16. Apply slip and attach feet. Blend seams.

19. Attach arm with slip; flatten arm so it blends into body at the shoulders.

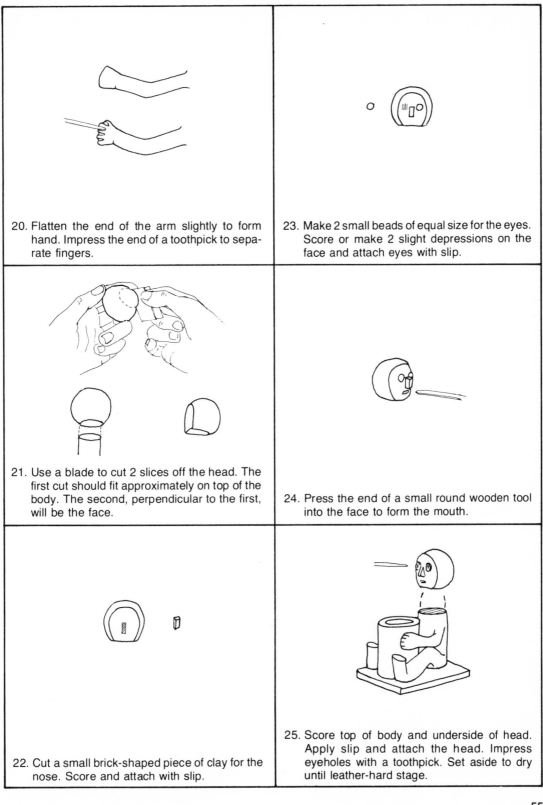

20. Flatten the end of the arm slightly to form hand. Impress the end of a toothpick to separate fingers.

21. Use a blade to cut 2 slices off the head. The first cut should fit approximately on top of the body. The second, perpendicular to the first, will be the face.

22. Cut a small brick-shaped piece of clay for the nose. Score and attach with slip.

23. Make 2 small beads of equal size for the eyes. Score or make 2 slight depressions on the face and attach eyes with slip.

24. Press the end of a small round wooden tool into the face to form the mouth.

25. Score top of body and underside of head. Apply slip and attach the head. Impress eyeholes with a toothpick. Set aside to dry until leather-hard stage.

26. Leather-hard stage. Carve nose to desired shape.

2. Make sure body is square and true. Draw a square on it by connecting pairs of points (represented here by a and b), each marked out ¾ unit from the corner. Smooth out lines falling outside the square.

## Vessel on Four Legs

Part of the construction of this project presents the method of carving a box from a block (as opposed to slab-building). This box becomes an ornamental vessel by the addition of legs, lid, and ears. The beveled edges are another feature.

3. Draw 4 pairs of lines as shown, using a ¼" balsa strip as ruler.

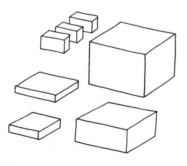

1. Prepare the following parts:
   3 blocks for ears and handle (each 1 x 1½ x 3)
   1 block for body (5 x 7 x 7)
   1 block for base (2 x 6 x 6)
   1 slab for lid (1 x 6½ x 6½)
   1 slab for lid collar (1 x 5 x 5)

4. Use a blade to cut a bevel on 4 sides, following the guidelines.

5. Begin the initial hollowing of the vessel. Don't go out to the guidelines yet, and don't dig deeper than ½″.

8. Apply slip to both pieces and join them. Blend seams.

6. Turn the body upside down and outline the base on it.

9. Place 1 ear in the center of the side of the body and outline it with a toothpick. Repeat on opposite side.

7. Score the 2 contact surfaces.

10. Score the 4 contact surfaces.

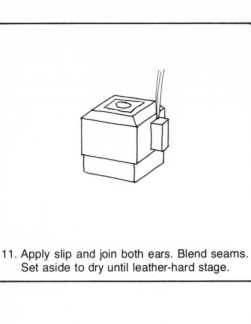

11. Apply slip and join both ears. Blend seams. Set aside to dry until leather-hard stage.

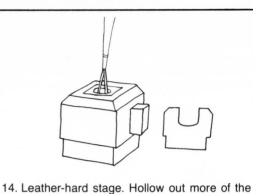

14. Leather-hard stage. Hollow out more of the cavity. When you reach wet clay, which sticks to the blade, stop the cutting and continue when the newly exposed clay dries leather-hard. Don't hollow out all the way to where the wall will finally be.

12. Outline collar on lid, score surfaces, apply slip, and join collar to lid. Blend seams.

15. Use a straw and then a knife to carve the ears and the lid handle. (This method is covered in "Box with Lid," steps 20–21, page 39.)

13. Outline the handle on the top side of the lid. Score the contact surfaces, apply slip, and join the 2 pieces. Blend seams.

16. Turn vessel upside down and draw 2 pairs of lines by connecting pairs of points, each point 2 units from the corner.

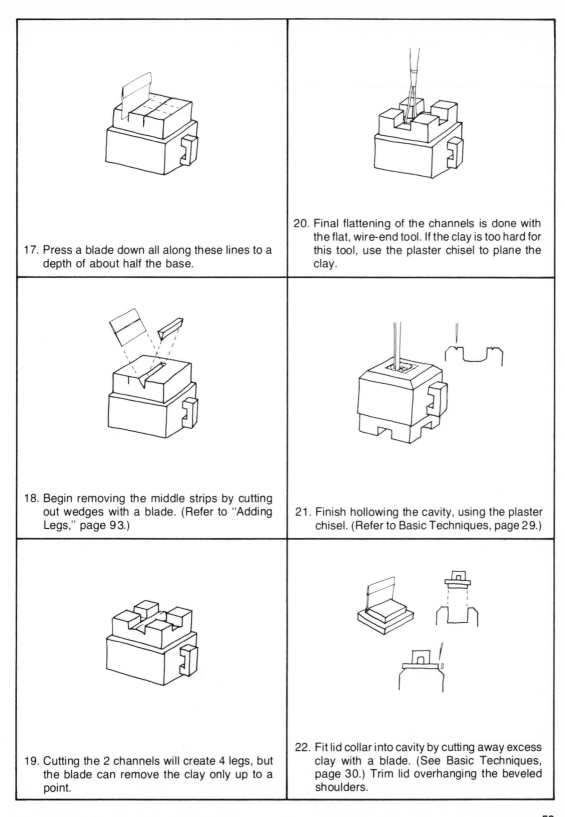

17. Press a blade down all along these lines to a depth of about half the base.

20. Final flattening of the channels is done with the flat, wire-end tool. If the clay is too hard for this tool, use the plaster chisel to plane the clay.

18. Begin removing the middle strips by cutting out wedges with a blade. (Refer to "Adding Legs," page 93.)

21. Finish hollowing the cavity, using the plaster chisel. (Refer to Basic Techniques, page 29.)

19. Cutting the 2 channels will create 4 legs, but the blade can remove the clay only up to a point.

22. Fit lid collar into cavity by cutting away excess clay with a blade. (See Basic Techniques, page 30.) Trim lid overhanging the beveled shoulders.

# 7. Projects: Section II

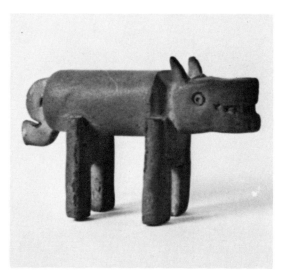 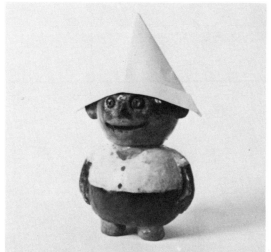

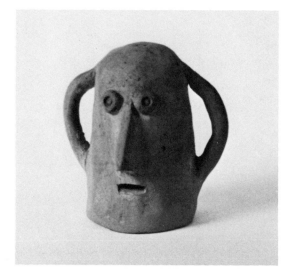 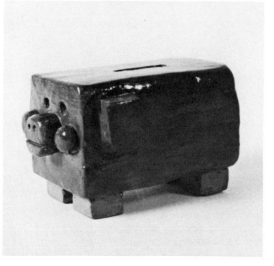

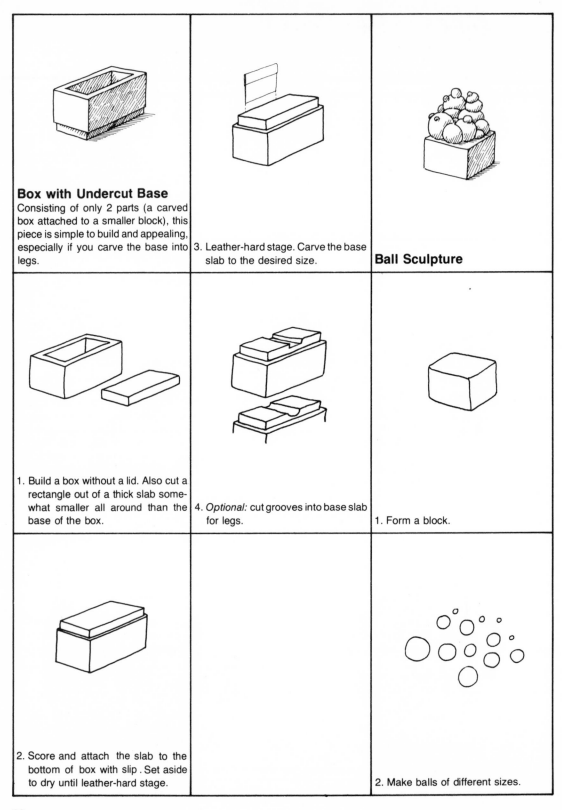

## Box with Undercut Base

Consisting of only 2 parts (a carved box attached to a smaller block), this piece is simple to build and appealing, especially if you carve the base into legs.

3. Leather-hard stage. Carve the base slab to the desired size.

## Ball Sculpture

1. Build a box without a lid. Also cut a rectangle out of a thick slab somewhat smaller all around than the base of the box.

4. *Optional:* cut grooves into base slab for legs.

1. Form a block.

2. Score and attach the slab to the bottom of box with slip. Set aside to dry until leather-hard stage.

2. Make balls of different sizes.

3. Attach, with scoring and slip, the large balls and continue with small ones. Press each ball down well after attaching.

**Stylized Animal**
This stylized animal consists of only a few simple geometric solids.

3. Attach with slip and blend 2 small pieces of clay for the ears. Lay the piece on its back and rest the piece so that the ears do not touch the support.

4. A great number of original variations are possible by changing sizes and arrangement of balls.

1. Make a cylinder and a block of roughly equal height.

4. Cut 2 leg slabs at the same time to ensure equal size. The slabs should be slightly wider than the diameter of the body cylinder. Cut out a rough semicircle to fit the cylinder body. Also cut a slab for the tail. Attach all 3 pieces with scoring and slip. Dry to leather-hard stage (slowly and with care so that the legs don't bend—or even fall off). Keep piece on its back while drying.

2. Score, apply slip, and join the 2 pieces.

5. Leather-hard stage. Impress eyes, nostrils, mouth, and teeth. Carve ears and tail and separation between legs. Don't stand animal on legs until clay is completely dry.

## Block Bear

This is one of the easiest ways to construct an animal. The entire piece is nothing more than a flattened cylinder and a few surface appendages.

3. Attach the following with scoring and slip: ears (from slab); muzzle (a cylinder); pellets for eyes; 2 blocks for front feet; 2 L-shaped slabs for hind feet; small slab for tail. Cut legs sandwiched, 2 at a time, so that they'll be the same size.

## Pebble Man

This type of figurine is usually built by gluing pebbles together, but making it out of clay is just as simple, especially since nice round stones are hard to find.

1. Form a cylinder. Flatten cylinder by gradually thumping it against the bat or work surface.

4. To speed drying, hollow out some of the bottom. Dry until leather-hard stage.

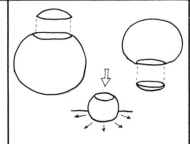

1. Form 2 balls, 1 for the body and 1 for the head. (The body should be equal to or bigger than the head, otherwise the figure might topple.) Throw the body down on the bat to flatten its bottom. Slice off the top of each piece. Try to get the flat, cut surfaces about the same size.

2. Slice off desired length for body.

5. Leather-hard stage. Impress nostrils and eyeballs; impress or cut mouth. Carve off sharp edges if you want a bear with softer contours.

2. Attach head to body. *Optional:* make the feet by flattening 3 small balls. Set aside to dry. (Figure can be left without feet.)

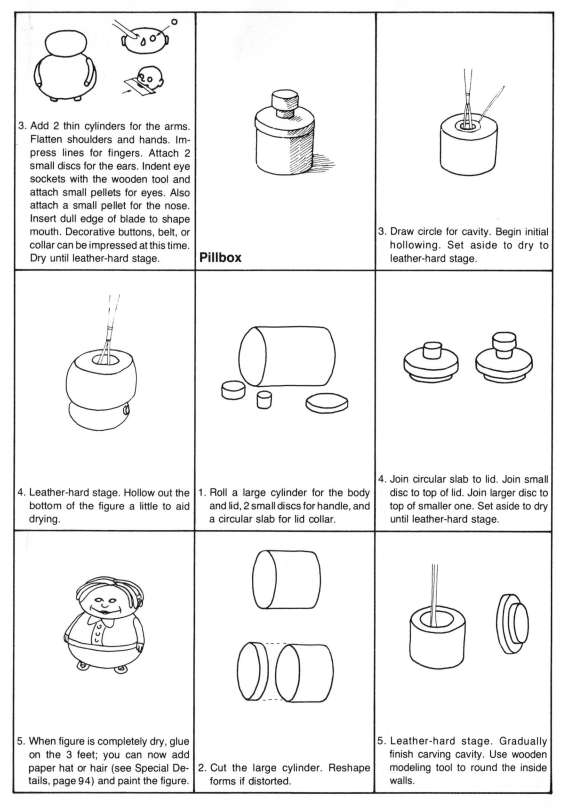

3. Add 2 thin cylinders for the arms. Flatten shoulders and hands. Impress lines for fingers. Attach 2 small discs for the ears. Indent eye sockets with the wooden tool and attach small pellets for eyes. Also attach a small pellet for the nose. Insert dull edge of blade to shape mouth. Decorative buttons, belt, or collar can be impressed at this time. Dry until leather-hard stage.

**Pillbox**

3. Draw circle for cavity. Begin initial hollowing. Set aside to dry to leather-hard stage.

4. Leather-hard stage. Hollow out the bottom of the figure a little to aid drying.

1. Roll a large cylinder for the body and lid, 2 small discs for handle, and a circular slab for lid collar.

4. Join circular slab to lid. Join small disc to top of lid. Join larger disc to top of smaller one. Set aside to dry until leather-hard stage.

5. When figure is completely dry, glue on the 3 feet; you can now add paper hat or hair (see Special Details, page 94) and paint the figure.

2. Cut the large cylinder. Reshape forms if distorted.

5. Leather-hard stage. Gradually finish carving cavity. Use wooden modeling tool to round the inside walls.

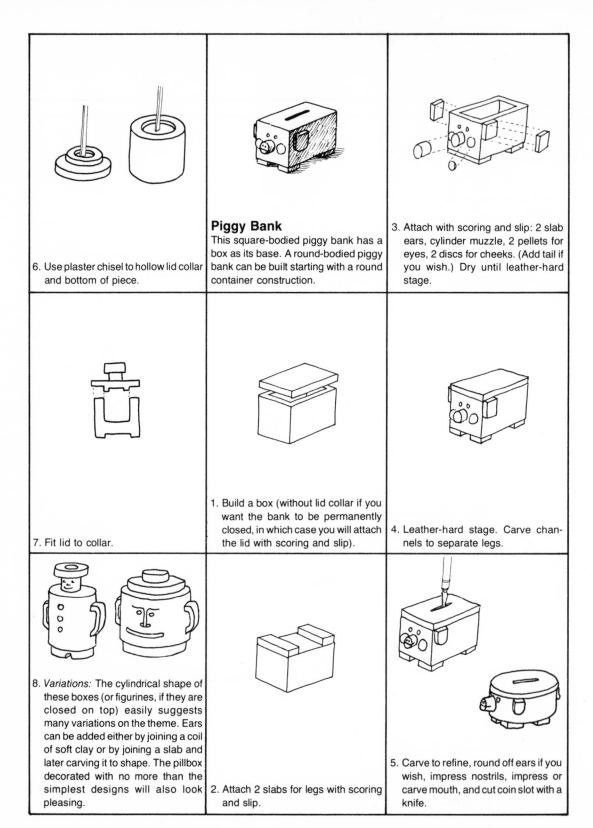

6. Use plaster chisel to hollow lid collar and bottom of piece.

**Piggy Bank**
This square-bodied piggy bank has a box as its base. A round-bodied piggy bank can be built starting with a round container construction.

3. Attach with scoring and slip: 2 slab ears, cylinder muzzle, 2 pellets for eyes, 2 discs for cheeks. (Add tail if you wish.) Dry until leather-hard stage.

7. Fit lid to collar.

1. Build a box (without lid collar if you want the bank to be permanently closed, in which case you will attach the lid with scoring and slip).

4. Leather-hard stage. Carve channels to separate legs.

8. *Variations:* The cylindrical shape of these boxes (or figurines, if they are closed on top) easily suggests many variations on the theme. Ears can be added either by joining a coil of soft clay or by joining a slab and later carving it to shape. The pillbox decorated with no more than the simplest designs will also look pleasing.

2. Attach 2 slabs for legs with scoring and slip.

5. Carve to refine, round off ears if you wish, impress nostrils, impress or carve mouth, and cut coin slot with a knife.

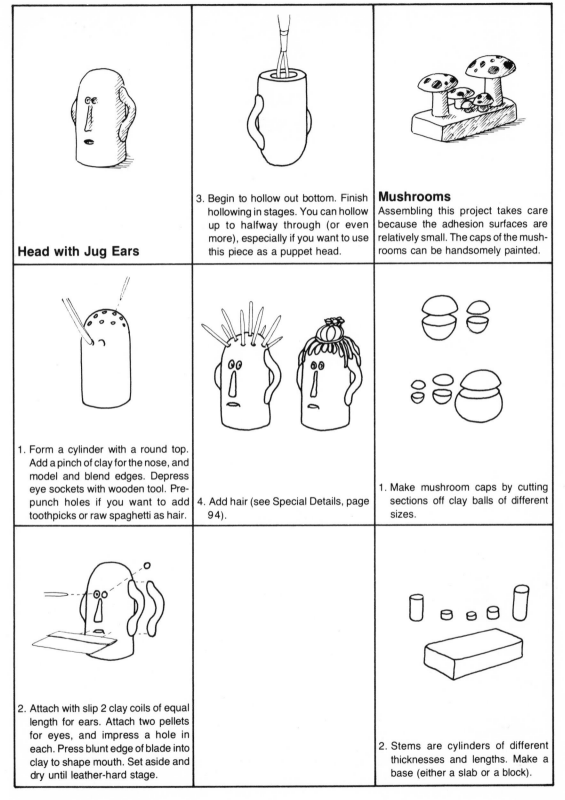

**Head with Jug Ears**

3. Begin to hollow out bottom. Finish hollowing in stages. You can hollow up to halfway through (or even more), especially if you want to use this piece as a puppet head.

**Mushrooms**

Assembling this project takes care because the adhesion surfaces are relatively small. The caps of the mushrooms can be handsomely painted.

1. Form a cylinder with a round top. Add a pinch of clay for the nose, and model and blend edges. Depress eye sockets with wooden tool. Prepunch holes if you want to add toothpicks or raw spaghetti as hair.

4. Add hair (see Special Details, page 94).

1. Make mushroom caps by cutting sections off clay balls of different sizes.

2. Attach with slip 2 clay coils of equal length for ears. Attach two pellets for eyes, and impress a hole in each. Press blunt edge of blade into clay to shape mouth. Set aside and dry until leather-hard stage.

2. Stems are cylinders of different thicknesses and lengths. Make a base (either a slab or a block).

67

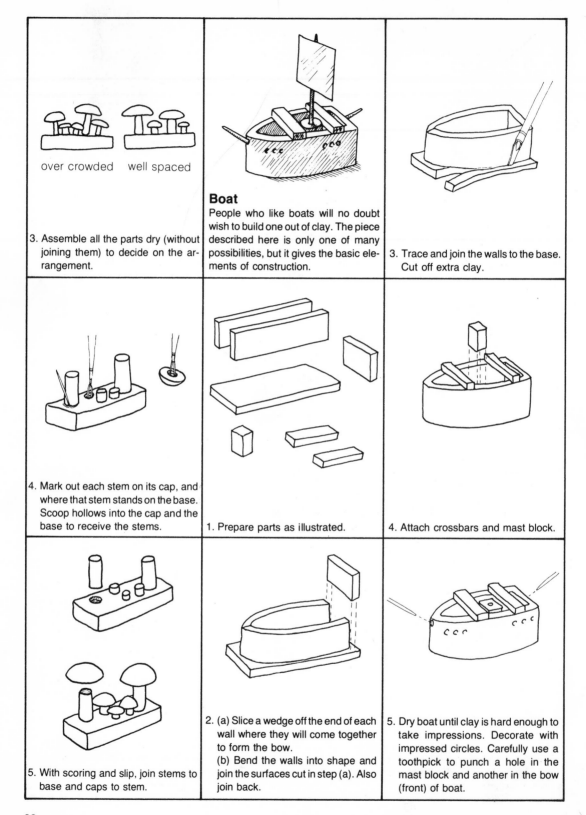

over crowded    well spaced

3. Assemble all the parts dry (without joining them) to decide on the arrangement.

**Boat**
People who like boats will no doubt wish to build one out of clay. The piece described here is only one of many possibilities, but it gives the basic elements of construction.

3. Trace and join the walls to the base. Cut off extra clay.

4. Mark out each stem on its cap, and where that stem stands on the base. Scoop hollows into the cap and the base to receive the stems.

1. Prepare parts as illustrated.

4. Attach crossbars and mast block.

5. With scoring and slip, join stems to base and caps to stem.

2. (a) Slice a wedge off the end of each wall where they will come together to form the bow.
(b) Bend the walls into shape and join the surfaces cut in step (a). Also join back.

5. Dry boat until clay is hard enough to take impressions. Decorate with impressed circles. Carefully use a toothpick to punch a hole in the mast block and another in the bow (front) of boat.

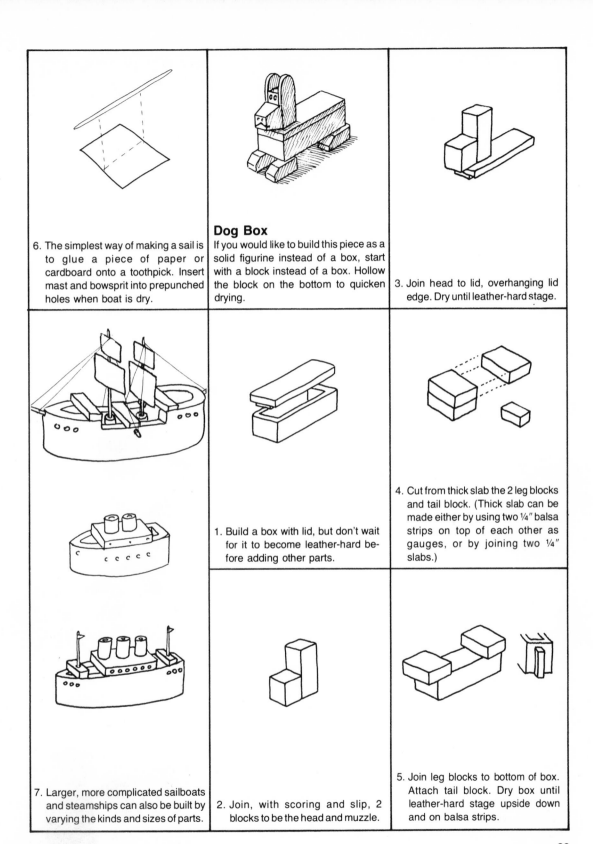

6. The simplest way of making a sail is to glue a piece of paper or cardboard onto a toothpick. Insert mast and bowsprit into prepunched holes when boat is dry.

**Dog Box**

If you would like to build this piece as a solid figurine instead of a box, start with a block instead of a box. Hollow the block on the bottom to quicken drying.

3. Join head to lid, overhanging lid edge. Dry until leather-hard stage.

1. Build a box with lid, but don't wait for it to become leather-hard before adding other parts.

4. Cut from thick slab the 2 leg blocks and tail block. (Thick slab can be made either by using two ¼″ balsa strips on top of each other as gauges, or by joining two ¼″ slabs.)

7. Larger, more complicated sailboats and steamships can also be built by varying the kinds and sizes of parts.

2. Join, with scoring and slip, 2 blocks to be the head and muzzle.

5. Join leg blocks to bottom of box. Attach tail block. Dry box until leather-hard stage upside down and on balsa strips.

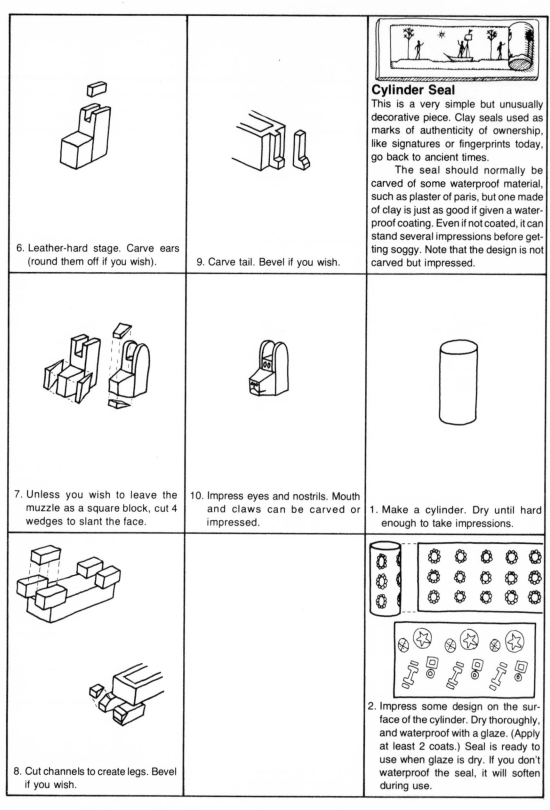

6. Leather-hard stage. Carve ears (round them off if you wish).

9. Carve tail. Bevel if you wish.

### Cylinder Seal

This is a very simple but unusually decorative piece. Clay seals used as marks of authenticity of ownership, like signatures or fingerprints today, go back to ancient times.

The seal should normally be carved of some waterproof material, such as plaster of paris, but one made of clay is just as good if given a waterproof coating. Even if not coated, it can stand several impressions before getting soggy. Note that the design is not carved but impressed.

7. Unless you wish to leave the muzzle as a square block, cut 4 wedges to slant the face.

10. Impress eyes and nostrils. Mouth and claws can be carved or impressed.

1. Make a cylinder. Dry until hard enough to take impressions.

8. Cut channels to create legs. Bevel if you wish.

2. Impress some design on the surface of the cylinder. Dry thoroughly, and waterproof with a glaze. (Apply at least 2 coats.) Seal is ready to use when glaze is dry. If you don't waterproof the seal, it will soften during use.

3. Roll the seal on a slab, and you will
   have a continuous, regularly repeat-
   ing design. Trim imprint to rectangu-
   lar shape if you wish.

**Turtle Box**

3. Attach lid collar cut from a slab to
   the shell.

4. A nice way to mount a cylinder seal
   impression is to roll the seal directly
   onto a thick block or slab

1. Make a drum. Use a board to flatten
   the top evenly.

4. Shape legs and tail by slicing a thin
   cylinder. A thicker cylinder serves
   as the head.

2. Slice the drum in half.

5. Mark out the box opening and do
   the initial hollowing out. Dry until
   leather-hard stage.

6. Leather-hard stage. Bevel shell all around once or as many times as you wish. The more you bevel, the rounder the shell becomes.

9. Finish hollowing out the box. Round off head, legs, and tail by carving and/or using wooden modeling tool. Impress eyes. Impress or carve mouth and claws.

## Mobile

The construction of mobiles requires some planning in order to make them balance well. You can make trial designs using cardboard.

7. Hollow out lid collar.

10. Fit lid to box.

1. Outline mobile's blades on a slab.

8. The design on the shell can be made in 3 ways: (a) by a repeating circular or square impression; (b) by impressing lines, using a plaster chisel; or (c) by rocking a toothpick or balsa-strip edge on the surface.

2. Cut them out and dry them until stiff enough to be handled.

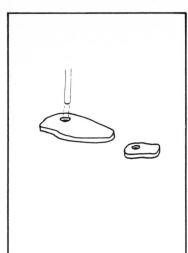

3. Punch holes in each blade.

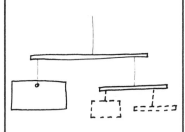

4. To assemble the mobile, on a long bar counterbalance a blade and a shorter bar. The shorter bar holds another counterbalanced blade and bar. This motif can be repeated over and over. There are many other methods of constructing mobiles.

# 8. Projects: Section III

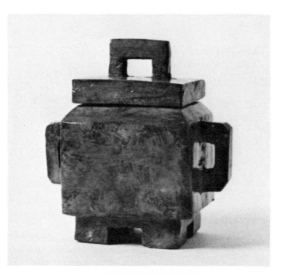

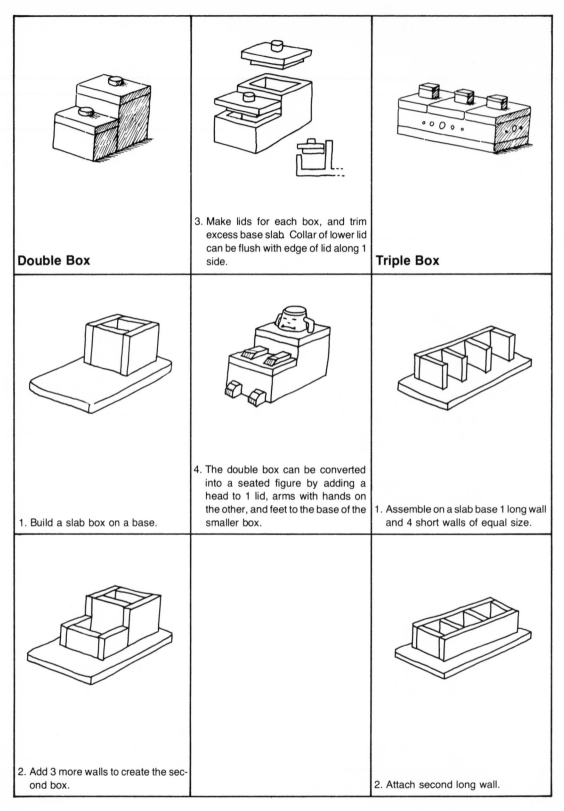

**Double Box**

3. Make lids for each box, and trim excess base slab. Collar of lower lid can be flush with edge of lid along 1 side.

**Triple Box**

1. Build a slab box on a base.

4. The double box can be converted into a seated figure by adding a head to 1 lid, arms with hands on the other, and feet to the base of the smaller box.

1. Assemble on a slab base 1 long wall and 4 short walls of equal size.

2. Add 3 more walls to create the second box.

2. Attach second long wall.

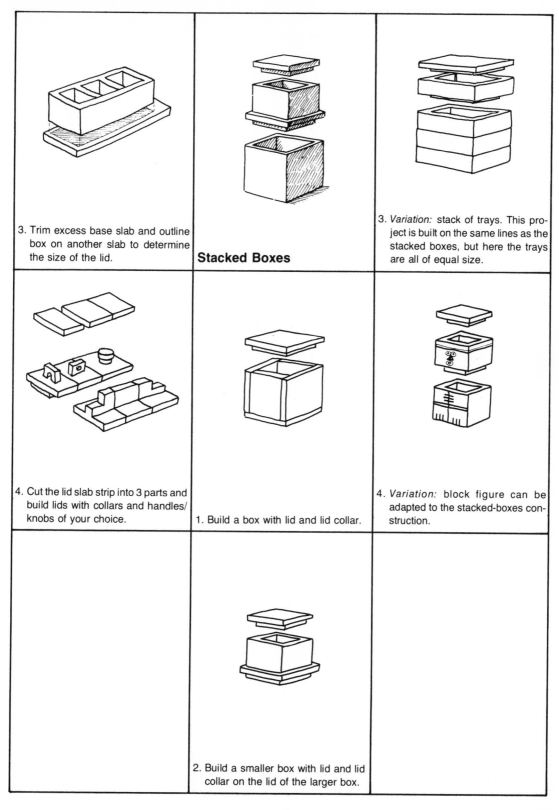

3. Trim excess base slab and outline box on another slab to determine the size of the lid.

**Stacked Boxes**

3. *Variation:* stack of trays. This project is built on the same lines as the stacked boxes, but here the trays are all of equal size.

4. Cut the lid slab strip into 3 parts and build lids with collars and handles/knobs of your choice.

1. Build a box with lid and lid collar.

4. *Variation:* block figure can be adapted to the stacked-boxes construction.

2. Build a smaller box with lid and lid collar on the lid of the larger box.

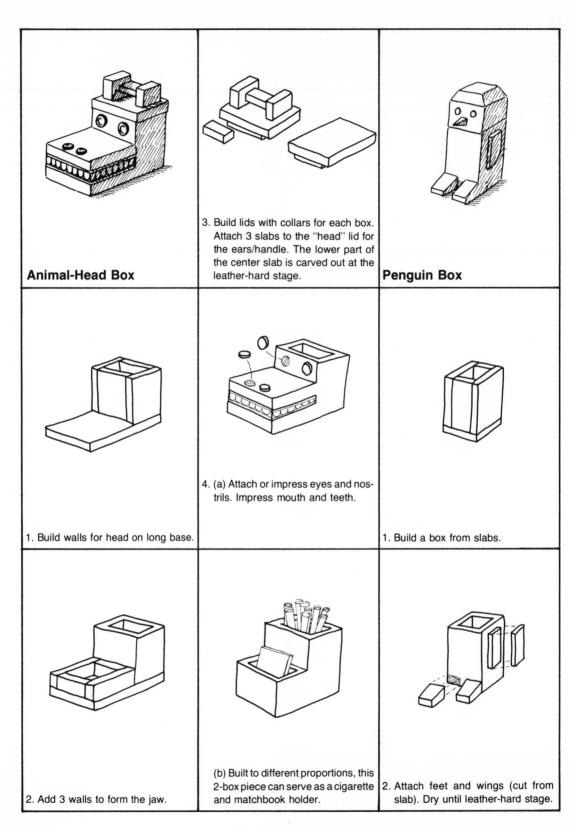

**Animal-Head Box**

3. Build lids with collars for each box. Attach 3 slabs to the "head" lid for the ears/handle. The lower part of the center slab is carved out at the leather-hard stage.

**Penguin Box**

4. (a) Attach or impress eyes and nostrils. Impress mouth and teeth.

1. Build walls for head on long base.

1. Build a box from slabs.

2. Add 3 walls to form the jaw.

(b) Built to different proportions, this 2-box piece can serve as a cigarette and matchbook holder.

2. Attach feet and wings (cut from slab). Dry until leather-hard stage.

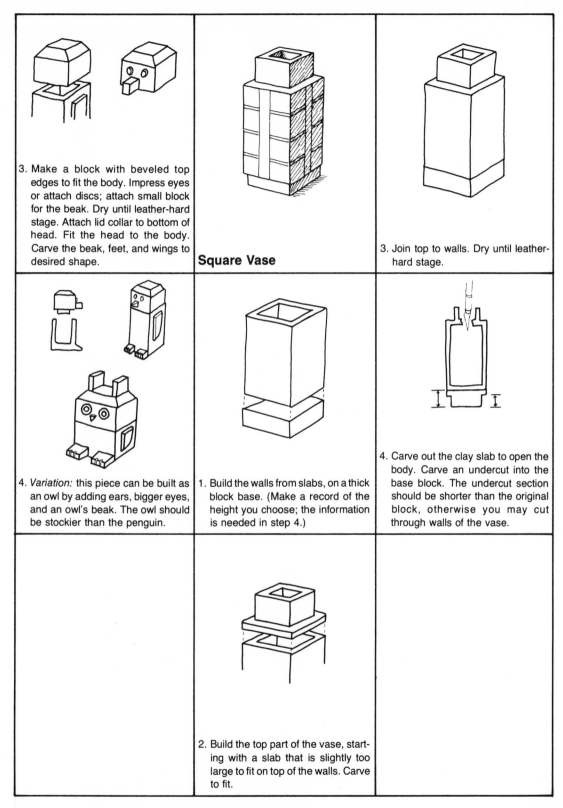

3. Make a block with beveled top edges to fit the body. Impress eyes or attach discs; attach small block for the beak. Dry until leather-hard stage. Attach lid collar to bottom of head. Fit the head to the body. Carve the beak, feet, and wings to desired shape.

**Square Vase**

3. Join top to walls. Dry until leather-hard stage.

4. *Variation:* this piece can be built as an owl by adding ears, bigger eyes, and an owl's beak. The owl should be stockier than the penguin.

1. Build the walls from slabs, on a thick block base. (Make a record of the height you choose; the information is needed in step 4.)

4. Carve out the clay slab to open the body. Carve an undercut into the base block. The undercut section should be shorter than the original block, otherwise you may cut through walls of the vase.

2. Build the top part of the vase, starting with a slab that is slightly too large to fit on top of the walls. Carve to fit.

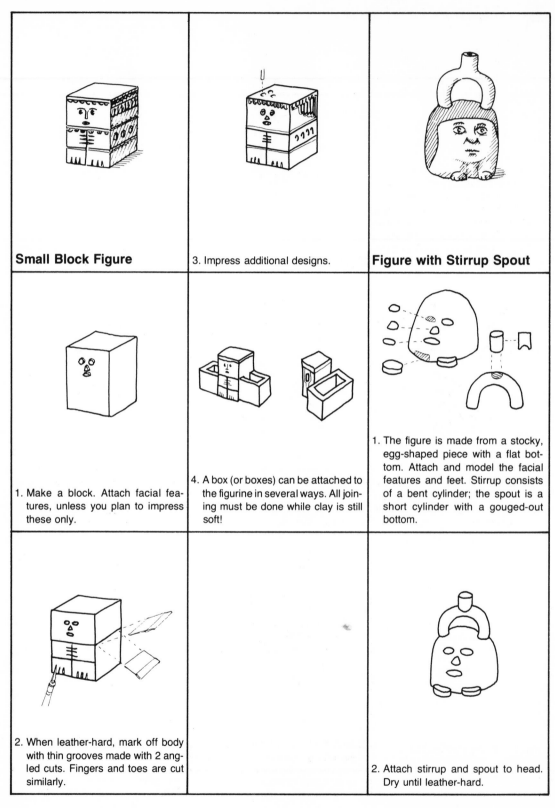

**Small Block Figure**

3. Impress additional designs.

**Figure with Stirrup Spout**

1. Make a block. Attach facial features, unless you plan to impress these only.

4. A box (or boxes) can be attached to the figurine in several ways. All joining must be done while clay is still soft!

1. The figure is made from a stocky, egg-shaped piece with a flat bottom. Attach and model the facial features and feet. Stirrup consists of a bent cylinder; the spout is a short cylinder with a gouged-out bottom.

2. When leather-hard, mark off body with thin grooves made with 2 angled cuts. Fingers and toes are cut similarly.

2. Attach stirrup and spout to head. Dry until leather-hard.

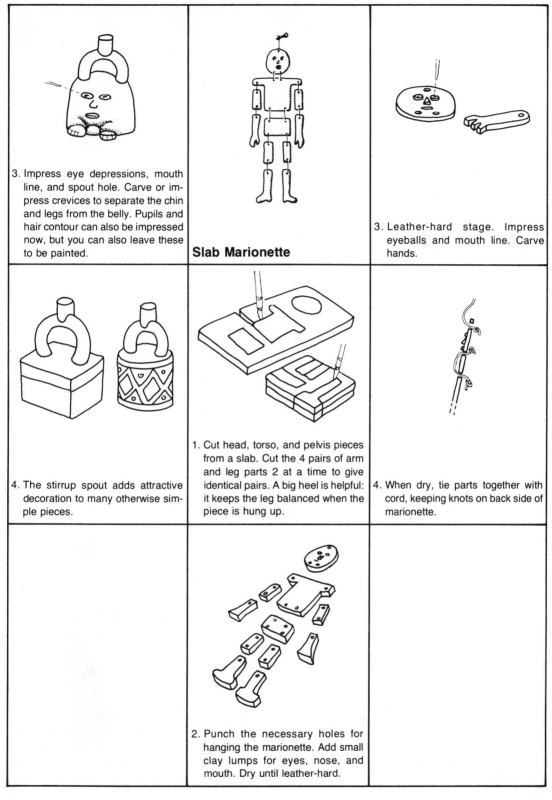

3. Impress eye depressions, mouth line, and spout hole. Carve or impress crevices to separate the chin and legs from the belly. Pupils and hair contour can also be impressed now, but you can also leave these to be painted.

**Slab Marionette**

3. Leather-hard stage. Impress eyeballs and mouth line. Carve hands.

4. The stirrup spout adds attractive decoration to many otherwise simple pieces.

1. Cut head, torso, and pelvis pieces from a slab. Cut the 4 pairs of arm and leg parts 2 at a time to give identical pairs. A big heel is helpful: it keeps the leg balanced when the piece is hung up.

4. When dry, tie parts together with cord, keeping knots on back side of marionette.

2. Punch the necessary holes for hanging the marionette. Add small clay lumps for eyes, nose, and mouth. Dry until leather-hard.

**Animal with Large Face**

3. Leather-hard stage. Carve or impress the mouth and teeth.

**Bug**

1. Attach a large and a small cylinder.

4. Gluing on a length of wood (dowel or popsicle stick) makes this creature into a puppet.

1. Attach 2 slab circles to elliptical slab body, and then attach body to leg block.

2. Add ears, eyes, nose, feet, and tail. Dry until leather-hard.

2. When the clay is of the proper consistency, impress pupils, lines, decorative dots, and mouth. Dry until leather-hard stage.

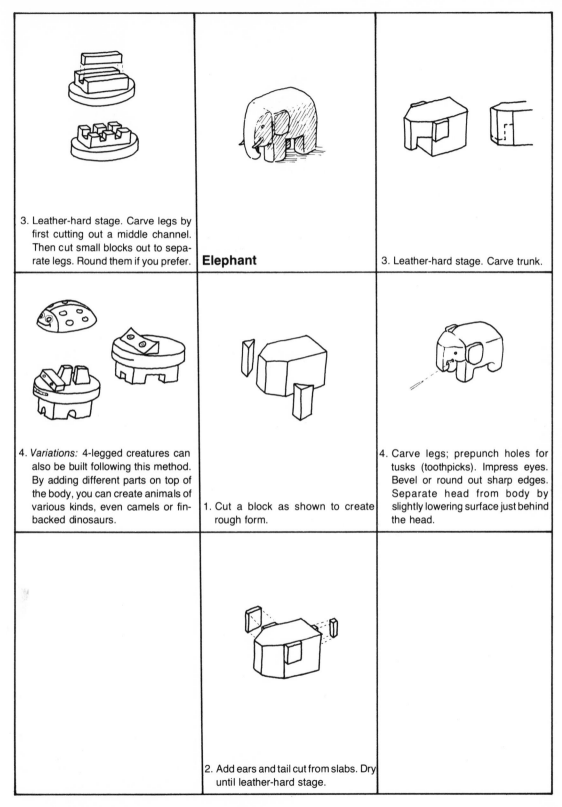

3. Leather-hard stage. Carve legs by first cutting out a middle channel. Then cut small blocks out to separate legs. Round them if you prefer.

**Elephant**

3. Leather-hard stage. Carve trunk.

4. *Variations:* 4-legged creatures can also be built following this method. By adding different parts on top of the body, you can create animals of various kinds, even camels or fin-backed dinosaurs.

1. Cut a block as shown to create rough form.

4. Carve legs; prepunch holes for tusks (toothpicks). Impress eyes. Bevel or round out sharp edges. Separate head from body by slightly lowering surface just behind the head.

2. Add ears and tail cut from slabs. Dry until leather-hard stage.

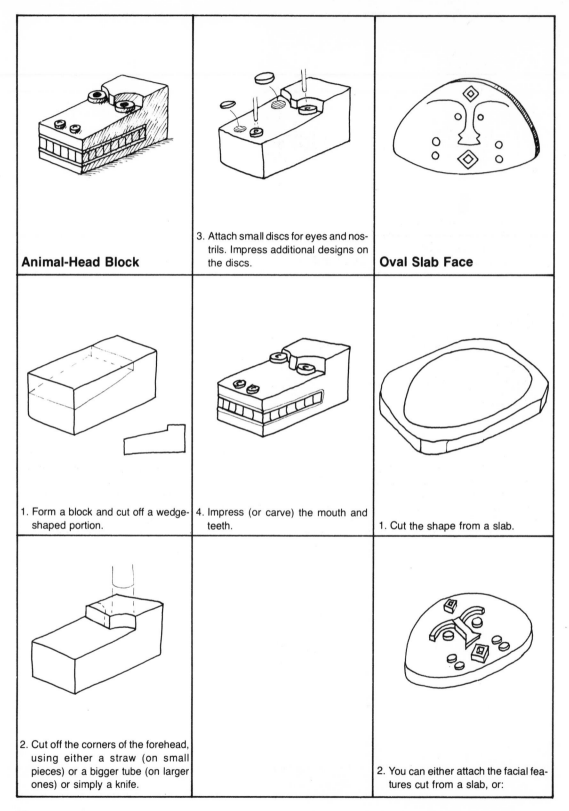

**Animal-Head Block**

3. Attach small discs for eyes and nostrils. Impress additional designs on the discs.

**Oval Slab Face**

1. Form a block and cut off a wedge-shaped portion.

4. Impress (or carve) the mouth and teeth.

1. Cut the shape from a slab.

2. Cut off the corners of the forehead, using either a straw (on small pieces) or a bigger tube (on larger ones) or simply a knife.

2. You can either attach the facial features cut from a slab, or:

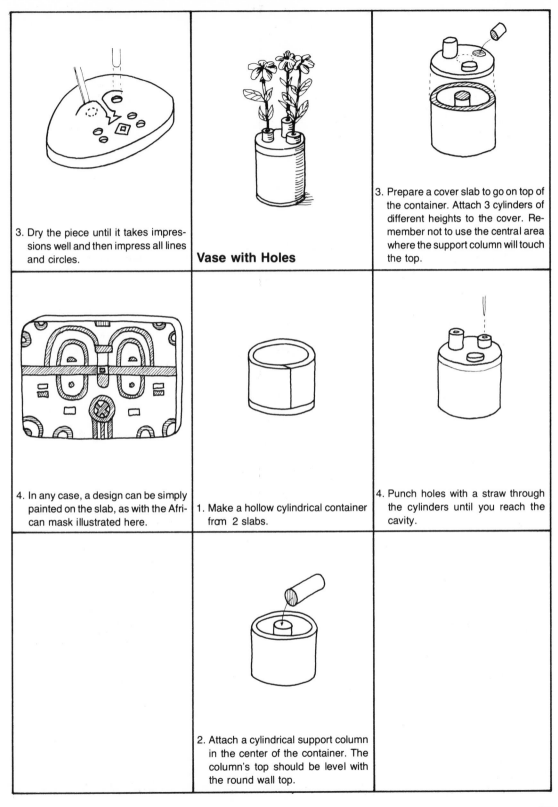

3. Dry the piece until it takes impressions well and then impress all lines and circles.

**Vase with Holes**

3. Prepare a cover slab to go on top of the container. Attach 3 cylinders of different heights to the cover. Remember not to use the central area where the support column will touch the top.

4. In any case, a design can be simply painted on the slab, as with the African mask illustrated here.

1. Make a hollow cylindrical container from 2 slabs.

4. Punch holes with a straw through the cylinders until you reach the cavity.

2. Attach a cylindrical support column in the center of the container. The column's top should be level with the round wall top.

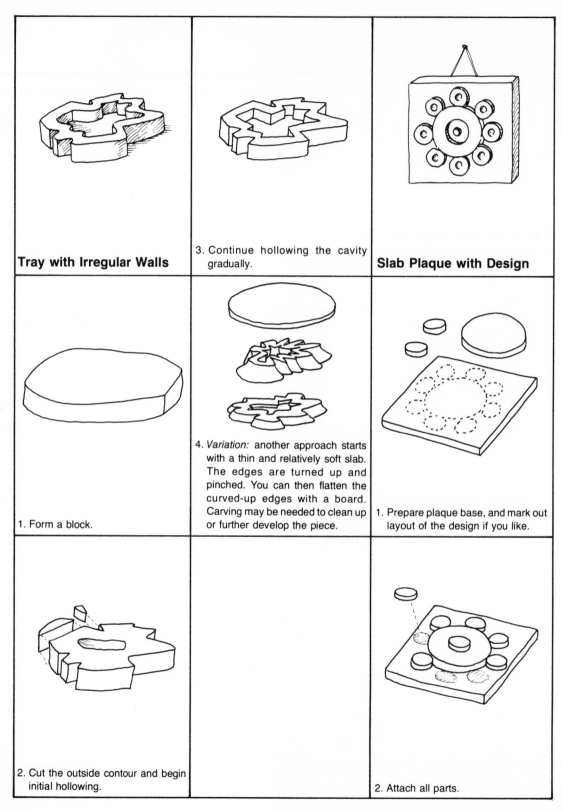

**Tray with Irregular Walls**

3. Continue hollowing the cavity gradually.

**Slab Plaque with Design**

1. Form a block.

4. *Variation:* another approach starts with a thin and relatively soft slab. The edges are turned up and pinched. You can then flatten the curved-up edges with a board. Carving may be needed to clean up or further develop the piece.

1. Prepare plaque base, and mark out layout of the design if you like.

2. Cut the outside contour and begin initial hollowing.

2. Attach all parts.

3. When clay is hard enough, apply impressions.

**Paperweight**

3. Impress design of your choice when clay is hard enough. If you plan to paint it only, then just let the piece dry fully.

4. Many other designs are possible. (For hanging the plaque, see Special Details, page 92.)

1. This piece is built from a block and slabs.

4. If you punch holes into the block, it can serve as a base for dried flowers.

2. Assemble piece.

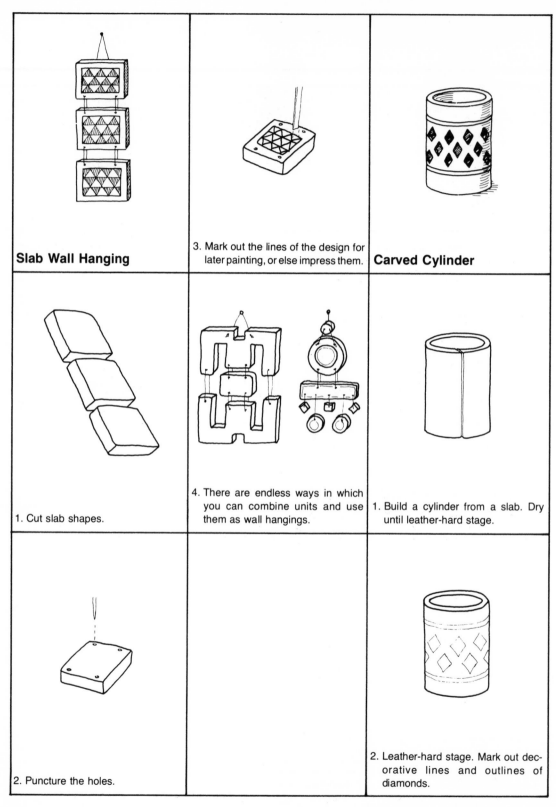

**Slab Wall Hanging**

3. Mark out the lines of the design for later painting, or else impress them.

**Carved Cylinder**

1. Cut slab shapes.

4. There are endless ways in which you can combine units and use them as wall hangings.

1. Build a cylinder from a slab. Dry until leather-hard stage.

2. Puncture the holes.

2. Leather-hard stage. Mark out decorative lines and outlines of diamonds.

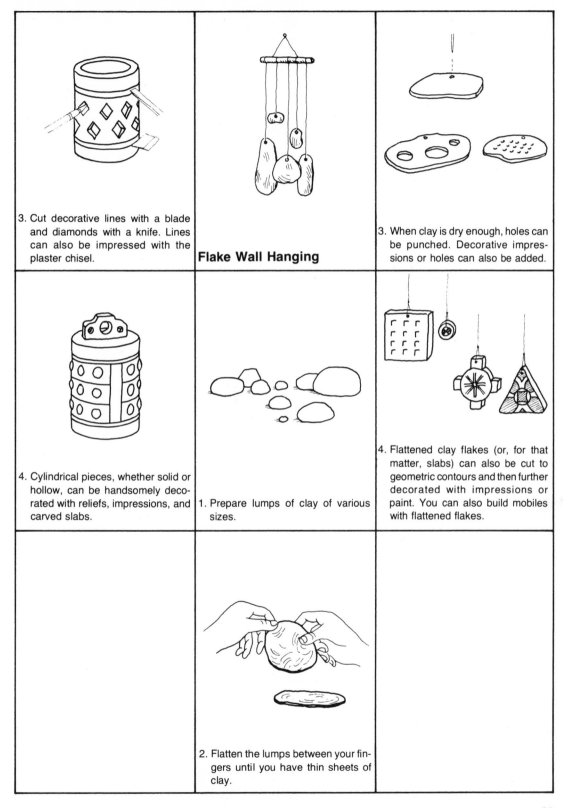

3. Cut decorative lines with a blade and diamonds with a knife. Lines can also be impressed with the plaster chisel.

**Flake Wall Hanging**

3. When clay is dry enough, holes can be punched. Decorative impressions or holes can also be added.

4. Cylindrical pieces, whether solid or hollow, can be handsomely decorated with reliefs, impressions, and carved slabs.

1. Prepare lumps of clay of various sizes.

4. Flattened clay flakes (or, for that matter, slabs) can also be cut to geometric contours and then further decorated with impressions or paint. You can also build mobiles with flattened flakes.

2. Flatten the lumps between your fingers until you have thin sheets of clay.

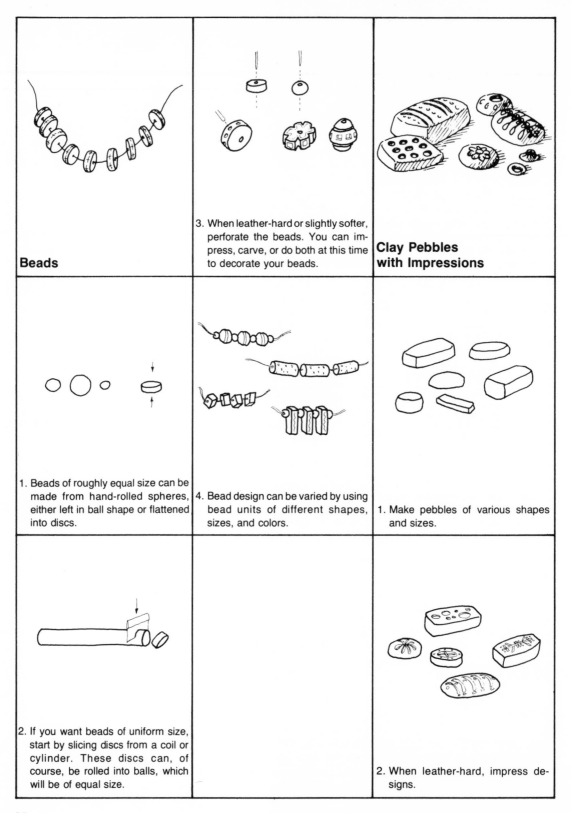

**Beads**

3. When leather-hard or slightly softer, perforate the beads. You can impress, carve, or do both at this time to decorate your beads.

**Clay Pebbles with Impressions**

1. Beads of roughly equal size can be made from hand-rolled spheres, either left in ball shape or flattened into discs.

4. Bead design can be varied by using bead units of different shapes, sizes, and colors.

1. Make pebbles of various shapes and sizes.

2. If you want beads of uniform size, start by slicing discs from a coil or cylinder. These discs can, of course, be rolled into balls, which will be of equal size.

2. When leather-hard, impress designs.

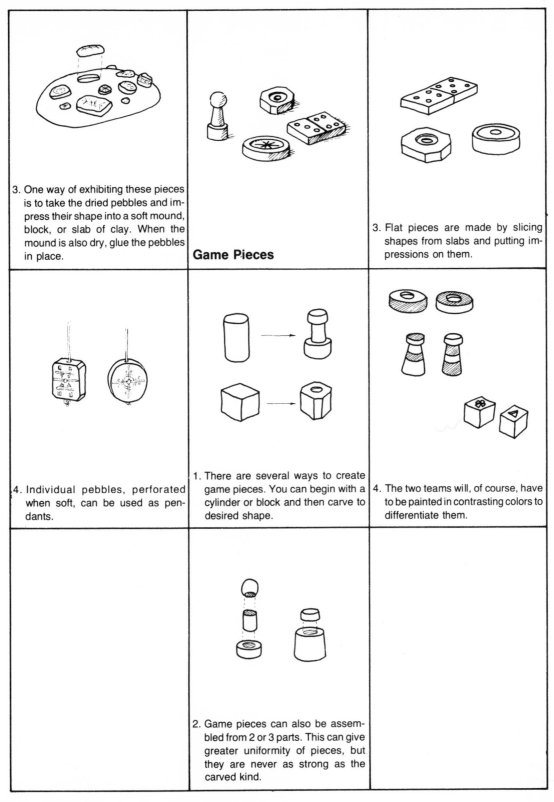

3. One way of exhibiting these pieces is to take the dried pebbles and impress their shape into a soft mound, block, or slab of clay. When the mound is also dry, glue the pebbles in place.

**Game Pieces**

3. Flat pieces are made by slicing shapes from slabs and putting impressions on them.

4. Individual pebbles, perforated when soft, can be used as pendants.

1. There are several ways to create game pieces. You can begin with a cylinder or block and then carve to desired shape.

4. The two teams will, of course, have to be painted in contrasting colors to differentiate them.

2. Game pieces can also be assembled from 2 or 3 parts. This can give greater uniformity of pieces, but they are never as strong as the carved kind.

91

# 9. Special Details

## How to Hang Wall Decorations

Slab pieces with hollowed-out backs can be simply hung on a nail (a). If the back is not hollowed, punch or carve a pit to hold the nail (b). If the piece is not easily balanced, you can cut a long groove, which will necessarily include the point of equilibrium (c).

(a)

(b)

(c)

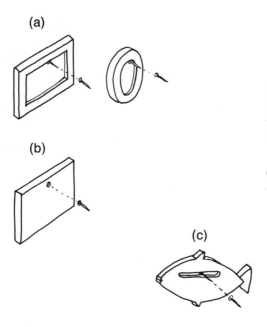

If you don't mind nails or cords showing, simply punch one or two holes through the slab and then hang the piece by putting nails or cord through the holes (d).

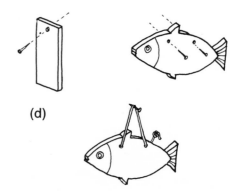

(d)

If the piece is thick enough, you can punch a hole diagonally, entering on the top surface and exiting out the back. This way the nails or cord will not interfere with the design (e).

Another way to hang a piece is to carve one or more eyelets that will hold nail or cord (f).

(e)

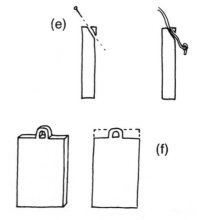

(f)

## Adding Legs

Separate legs can be joined to a piece with scoring and slip, but with this method the presence of joints makes the piece somewhat weak. If you choose this method, keep the attached legs relatively short and stocky (a), because long or thin ones can easily bend or break off while drying.

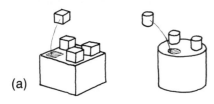

(a)

It is safer to attach a slab (for short legs) or a block (for longer ones) onto the bottom of the piece. When leather-hard, the slab or block can be carved into legs of varying design (b, c).

Legs can be carved directly from the body of a piece. Since there are no joints, there are none of the problems that arise from attaching separate legs (d).

(d)

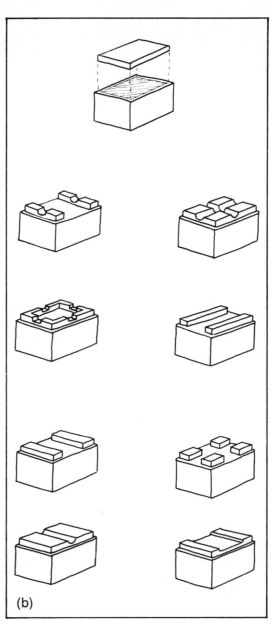

(b)

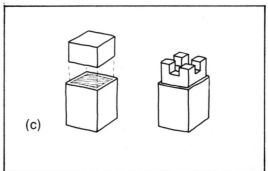

(c)

## Adding Hair

1. Toothpicks, raw spaghetti, wire, and so on, can be used as hair, bristles, or spines. Prepunch the holes while the clay is still soft, and when the piece is dry, insert the "hairs" (a). (Glue them in if you like.)

(d)

d. Glue on a tassel as a hairpiece (e).

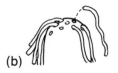

(a)

2. Soft hair (yarn, cord, string, and so on) can be added to a figure in several ways.

a. Coat ends of "hairs" with glue and push into prepunched holes (b).

(e)

(b)

b. Make a depression in the soft clay. Place end of the "hair" into the depression and secure it by plugging the hole with a small piece of clay (c).

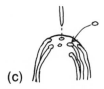

(c)

c. Glue "hair" on, strand by strand. Lay strands out across the head, or after a design of your own choice (d).

94

# Glossary

**Balsa strip.** Bar of balsa wood, square or rectangular in cross section, used in making clay slabs.

**Flexible steel palette.** A square or rectangular piece of thin steel sheet. Good for cutting soft clay and for cleaning clay from the work surface.

**Grog.** Pulverized clay that has been fired. It is permanently hard and will not shrink; adding it to clay makes a firmer modeling material that shrinks less.

**Impression.** The decorative mark made by pressing any object into clay.

**Leather-hard.** Condition of clay when it is dry enough to cut cleanly and without cracking, much like thick leather or soap.

**Lid collar.** A slab or wall on the bottom of a lid that fits into the opening of a vessel, so keeping the lid from sliding off.

**Plaster bat.** A square, rectangular, or round slab of plaster. The best surface for clay modeling because of its ability to absorb water.

**Plaster chisel.** A plaster sculpting tool, made of steel, with different blades at either end. Especially useful in carving clay past the leather-hard stage.

**Plastic stage.** Clay is in the plastic stage when it can be easily modeled, shaped, pulled, or rolled. (For carving or taking fine impressions, such clay is too soft.)

**Scoring.** Roughening the surfaces of clay pieces to be joined. Important for good adhesion.

**Self-hardening clay.** A mixture of clay, grog, and water-soluble hardener. This modeling medium dries considerably harder than regular clay. Finished, permanent pieces can be built from it without the use of a kiln.

**Slab.** A wide, flat piece of clay. The basic unit for certain types of clay modeling.

**Slip.** A wet, syrupy mixture of water and clay. Slip is essential in joining clay pieces and can also be used as a decorative finish.

**Wire cutting tool.** A length of strong, thin wire; the best tool for cleanly slicing soft clay.

**Wire-end modeling tool.** A wooden tool with different steel bands or wire loops at each end. A basic tool in clay modeling.

**Wooden modeling tool.** A basic tool of clay modeling, made of selected hard woods. Each end has a differently shaped blade or tip.

# Suppliers

**The Craftool Company, Inc.**
1421 West 240th Street
Harbor City, California 90710

**Westwood Ceramic Supply Company**
14400 Lomitas Avenue
City of Industry, California 91744

**Triarco Inc.**
3201 North Kimball Avenue
Chicago, Illinois 60618

**Dick Blick Company**
P.O. Box 1267
Galesburg, Illinois 61401

**Macmillan Arts and Crafts, Inc.**
9520 Baltimore Avenue
College Park, Maryland 20740

**Bergen Arts and Crafts, Inc.**
P.O. Box 381
Marblehead, Massachusetts 01945

**Boin Arts and Crafts Company**
87 Morris Street
Morristown, New Jersey 07960

**Allcraft Tool & Supply Company, Inc.**
215 Park Avenue
Hicksville, New York 11801

**Sculpture House**
38 East 30th Street
New York, New York 10016

**Stewart Clay Company, Inc.**
133 Mulberry Street
New York, New York 10013

**Capital Ceramics, Inc.**
2174 South Main Street
Salt Lake City, Utah 84115

**Earthworks, Inc.**
2309 West Main Street
Richmond, Virginia 23220

**Sax Arts & Crafts**
207 North Milwaukee Street
Milwaukee, Wisconsin 53202

*(Most of the supplies listed in this book can be found at home or purchased in local hardware or arts and crafts supply stores, as well.)*